MW01533167

WE WILL HAVE GAINED OURSELVES

WE WILL HAVE GAINED OURSELVES

Narrative Experiences of African Women Pursuing Higher Education in the United States of America

Mumbi Mwangi

NORTH STAR PRESS OF ST. CLOUD, INC.
St. Cloud, Minnesota

Copyright © 2009 Mumbi Mwangi

All rights reserved.

Printed in the United States of America

Published by
North Star Press of St. Cloud, Inc.
PO Box 451
St. Cloud, Minnesota 56302

northstarpress.com

info@northstarpress.com

Contents

Chapter One

INTRODUCTION

It was only a few years back I had felt that to be a full being, I had to
be a mother, a wife, a worker, and a wonder-woman. I now realize
that what I was doing then was condemning myself to earthly hell.
~Buchi Emecheta, *Head Above Water*

Higher education is not readily available to most women in Africa. Because of gender biases and disparities in educational policy and programs, women seeking higher education in Africa not only struggle with limited educational opportunities, but also hostile patriarchal social and educational structures that isolate, frustrate and marginalize them.[1] In further discussing the shortcomings of education systems in Africa and the plight of African women in academia, Mbilinyi and Meena[2] observe that in hostile patriarchal educational environments women "must struggle for the right to exist—in circumstances that range from benign neglect to overt hostility and sabotage."[3] Historically, higher education in Africa has mainly been the domain of men.[4] The formal educational structures and social expectations during the colonial and present post-colonial eras have worked to limit women's access to higher education, as a result of which, the typical higher education student in many African countries has been defined as

male. Consequently, government educational policies, higher educational programs, scholarships, as well as the supervision of academic process within universities in Africa are planned from the perspective of the male student and, therefore, discriminate against women who seek higher education. In articulating reasons why some African women seek higher education abroad, Mbilinyi and Meena[5] contend that many African women are discouraged from seeking academic excellence in local universities because of the hostile and insensitive academic environment coupled with low completion rates. Studying abroad, however, ensures a timely completion and acquisition of higher degrees. Many universities abroad also offer a wider variety of choices from which women can choose their areas of specialization. In addition, studying abroad carries with it an aura of prestige enjoyed, until recently, by men who, unhindered by familial barriers, have enjoyed the benefits of those opportunities. However, deciding to go abroad for African women is often a bittersweet option because they must contend with being away from their families. Kiluva-Ndunda[6] sums up this dilemma when she says that "for me . . . the joy of winning a prestigious Canadian International Development Agency (CIDA) scholarship was shrouded by the reality of this . . . leaving my two young children . . . to pursue a master's degree in Canada."[7] African women who choose to further their studies outside of their countries suffer alienation and exclusion from mainstream traditions of the society as they wrestle with the "contradictions of motherhood and the development of [their] career."[8] However, their willingness to risk alienation, as this study shows, speaks to the dire need to reconsider and redefine the structure, programs, and policies of women's education in Africa.

In order to understand the women's experiences, I interviewed three women from three different countries in the eastern part of Africa who left their families behind to pursue higher education in the United States of America. By using women's stories, I explore and illuminate not only the experiences of pain, ambivalence, and struggle that the women faced in pursuit of higher education, but also the creativity and sense of agency with which they negotiated and pushed for educational opportunities abroad. In addition, by expressing the women's experiences of anger, helplessness, and defiance, I reveal a major tension between domesticity and education that inhibits their access to education.

In this chapter, I introduce the three women: Tausi, Tenji, and Tamara, who came to America to pursue higher education, leaving their families in Africa. Using some excerpts from their narratives, I set the stage from where the on-going tension between domesticity and education can be viewed and articulated. Then, I give an overview of the social, historical and political contexts that have been responsible for the struggle between domesticity and education in the lives of African women. Specifically, I discuss African culture, colonial influence, and post-colonial or contemporary Africa. I conceptualize the groundwork for the study by describing my personal experiences. I articulate women's shared consciousness as they envisioned the process of "gaining" themselves through engaging in this narrative research process.

Tausi, Tenji, and Tamara

Tausi[9]

I interviewed Tausi when she was a doctoral student in Agricultural Education at a large land grant university in the United States. She had just completed her master's degree and had been accepted into a doctoral program. She was in her late thirties, married, and a mother of three children—one girl and two boys, aged eleven, thirteen, and five, respectively. The children and her husband, Kim, remained in Africa. Tausi initially trained for two years as a secondary-school teacher and then went on to pursue a Bachelor of Education (B.Ed.) degree in Africa. One year after graduating with a Bachelor's degree, she was hired as an inspector of schools in charge of Agriculture in her country. And because this job required higher qualifications for further promotion, she decided to continue her education in the United States of America in 1996.

Leaving her family behind was a tough decision. She said, "It was very hard coming here [pause], I had to leave my husband and my three children behind. But, you see, without education you are nothing." Tausi made this statement in relation to African men's high social status as a result of their ability to own land even when they did not have an education. For the few women in Africa who are able to go to school, education becomes value-oriented asset necessary to carve a niche for themselves in the society.

Tenji[10]

Tenji, my second respondent, was in her late forties when I interviewed her. She attended Pesa (pseudonym) University abroad and graduated with a Ph.D. in Regional Planning. While Tenji was abroad pursuing her studies, her two boys, then aged four and eight years, her husband, and her fifteen-year-old stepdaughter remained in Africa. Tenji successfully completed her doctorate and returned to Africa and was hired to teach in one of the universities.

Tenji was born and raised in rural Africa. She watched her mother struggle to keep the family together with meager resources when her father was away in the city. Talking about her decision to pursue further studies abroad, she said:

> My mother's life has always haunted me . . . I wanted to be in the university teaching staff and I knew without a Ph.D., I can't go very far. . . So I decided to go [abroad] . . . You know, being adamant and . . . being selfish for the first time. Many people look at us as deserting [our] marital home, deserting [our] . . . husband. It is very discouraging but you have to deal with it.

Tenji's narrative experiences were particularly useful in illuminating the challenges of trying to fit back into society on her return to Africa.

Tamara[11]

Tamara, my third respondent was between fifty and sixty years old. Her three children have all graduated from college and have jobs in big cities in Africa. Tamara grew up in a rural village in Africa, and she was lucky to have parents who valued education. She attended graduate school in the United States in the early 1980s and obtained a Master's degree in Home Economics Education and later returned to Africa. She taught in one of the universities and held an administrative position as the acting director of Student Affairs.

Reflecting on the challenges of deciding to go back to school, Tamara stated that:

Even my supportive father asked why I wanted to go back to school. Most of my friends could not understand why a qualified woman who already had a job wanted to go out to study . . . so the community was not amused. But if I had listened, I wouldn't have come. I knew three women who went abroad and never finished because their husbands threatened to divorce them. They could not continue. They abandoned their studies and went back home.

Tamara's narratives are significant in revealing how difficult it is for an African woman to climb the professional and academic ladders even after attaining a higher degree.

For the most part, these three women have had to contend with marginality through alienation and exclusion because they project personal beliefs that contradict the common values of African tradition. Despite their different backgrounds, these women agreed that the pursuit of higher education abroad was an indication of tremendous personal strength, courage, and determination. They also viewed education as important for their personal and professional development. Their views about self-improvement through higher education, the pain and losses they experienced by being away from their families, their emotional and psychological ambivalence as they tried to redefine themselves, and the ways in which they dealt with these issues as women are the main focus for this study.

Their narratives also reveal how social systems and institutions perpetuate gender inequalities and stereotypes that inhibit African women's access to education. One of the most entrenched stereotypes is that African woman must be domestic. Narratives in this book will illuminate the struggles the three women in the study faced in the pursuit of higher education and also point out the creativity and agency with which they negotiated and pushed for opportunities. In the next section, I discuss the historical and social contexts that have shaped women's education.

HISTORICAL AND SOCIAL CONTEXTS OF AFRICAN WOMEN'S LIVES

Domesticity and the Struggle for Education

Women's access to education at all levels has been, and continues to be, a key issue in Africa.[12] Women continue to grapple with cultural, traditional, economic, and political structures that marginalize them. The stereotype that African women must be domestic is used, among other things, to place the African woman in her "natural" location within the domestic sphere.[13] This continued struggle between domesticity and education and its negative impact on women's education is a major concern, particularly when one recognizes the role of education in the development of the individual and society. Understanding why this tension exists and how it impacts women's access to education is paramount to this study. In the following section, I give a brief overview of domesticity and education in order to set the stage for interrogating women's narratives.

Domesticity

I have chosen to use the term "domesticity" rather than "motherhood" in discussing women's positionality because domesticity encompasses motherhood as well as the familial context, relationships, and obligations that make up the lives of women. Domesticity, therefore, includes the dynamic interplay of roles and social structures in the lives of women and the choices they make.

Domesticity is central to this study because it touches every woman's life in some way, and it is often seen as an axis on which women's lives revolve and evolve. Because of its centrality in the lives of women, my respondents and I perceived domesticity as the main organizing factor of women's lives and identity. Therefore, in this study I use the concept of domesticity as a thread that weaves through the women's narratives. Weaving domesticity across women's lives functions in several ways. First, in the process of weaving, the concept of domesticity is stripped of its culturally bestowed stability. As women deconstruct, reconstruct and reconstitute it throughout their narratives[14] the concept of domesticity becomes dynamic and in constant flux. Because of this

6

dynamism, domesticity is not only defined differently by different women in the study; it also becomes open for further definitions and expansion. Second, by weaving domesticity throughout women's lives, this study is able to trace the changes over time of women's conception of domesticity in their lives. This conceptual change is important in illuminating the process by which women begin to project different forms of thinking about domesticity in a renewed, experiential way. As a result, therefore, domesticity not only means different things to different women, but it meant different things to the same women at different times in their lives. As their narratives show, the women in the study project a type of domesticity that is no longer a site of women's oppression and limitation. Instead, domesticity becomes a site of self-exploration and empowerment, a site, not of silence but of voice, a site, not of "self-*less*-ness" but of "self-*full*-ness."

A mention of another usage of the word "domesticity" is important here. I use the term "domesticity" to refer to an ideology that embodies and authorizes normative gender-differentiated roles and beliefs about masculinity and femininity in society. Based on this gendered ideology of domesticity, women's roles in many contexts are defined as reproductive rather than productive. Thus, women's place is seen to be in the home and their identity is constructed in relation to their roles in the domestic sphere. Domesticity as an ideology, therefore, requires women to function in no other context than the home because home is what defines them.

This view of domesticity is important for this study because it reveals the problem African society has in defining and locating African women who choose to function outside of the home. Because women who seek to futher their education are seen as functioning outside of the home, they often become victims of social wrath. Tenji articulates the tension of the "undefinable," educated, African woman as she relates her experience in a male-dominated academic environment where she is one of the few professional women with a doctorate, who is also a mother and wife. Tenji says of the men, "They fear you because they do not know how to define and to relate with you." As Tenji's story will reveal, education becomes a tool for alienation not only when women leave to go for further studies abroad but also when they get back home.

7

Finally, I use domesticity as a category of analysis and relate it to the gendered roles and positions in the lives of women in order to understand how they make meaning of everyday experiences. Domesticity as a category of analysis looks at the multiplicity of women's lives in relation to social, cultural, economic and political structures. I argue that the impact of these structures on domesticity has certain implications for women's education. For example, using domesticity as a category of analysis when evaluating factors that impact women's economic status helps to pin-point problems like mother-work as unpaid labor, the value of education as a measure of economic potential, and education and domesticity as oppositional discourses, all of which point to the ways domesticity short-changes African women.

Pertinent to this study is the societal assumption that motherhood and domesticity are incompatible with education and professional development.[15] Consequently, one of the major tensions that women in the study had to contend with was the guilt of leaving their families for an extended period of time to pursue an education abroad. Listening to the women's narratives of pain and anguish with which they made the choice between education and domesticity was excruciating. This moment called for a "heart of stone" not only in making the decision but also in "living" the decision. This is because when women make the decision in favor of education, they have, from a cultural perspective, threatened their own positions in society. Such a decision spells doom on the part of the woman's socially constructed self, because it challenges and threatens the core values that the society holds about what it means to be a woman and to be feminine. In such situations, a woman's decision to pursue education is not just a personal decision about a personal life but an act of deviance against the society. It follows, therefore, that in such instances, women find themselves in a contradictory "double bind" of allegiance to either the self or to the society. Using domesticity as a category of analysis illuminates, for example, why women in the study chose the allegiance to the former, rather than the latter, and what motivated them to make such choices. Domesticity as a category of analysis also allows me to critically look at women's narratives and to identify barriers to education and self-realization in a society that devalues women's autonomy.

Education

I use the term "education" to mean "formal education," which is acquired through attending schools at primary, secondary and higher education levels in Africa. Although this study focuses on women pursuing higher education, it was important to see the interconnectedness of factors that impinged upon women's education at every level of the educational cycle. Because the notions of incompatibility of formal education and domesticity are strongly entrenched in African societies, the tensions become distinct at a very early stage of socialization in women's lives. The tensions emanate from mixed cultural prescriptions about domesticity and the constraints that such prescriptions place on women's ability to pursue formal education.

It is important to distinguish between "formal" and "informal" education. The history of formal education in most African countries is associated with the coming of the white Christian missionaries from Europe. They established mission schools, as a way to further civilize the African peoples. Formal education required girls, for example, to move away from home to go to the mission schools.[16]

On the other hand, the informal African education was embedded in the everyday process of socializing girls from an early age. Girls were always around their mothers in order to learn skills and habits expected of them.[17] And because it was through informal education that domesticity was taught as a norm to women and girls, African traditionalism saw the formal education as a direct threat to the integrity of African cultural socialization of girls, and hence the tension between domesticity and education. As a result of these contradictions, women in Africa continue to view domesticity and formal education as two oppositional choices with contradictory demands compounded by strong cultural beliefs and taboos.[18]

Socio/Historical Context

In order to place this study into the proper context, I highlight the social and historical contexts within which African women function. Socio/historical contexts provide important aspects of "pastness" or the historical perspectives related to attitudes regarding women, education, and domesticity. A review of socio-historical context reveasl how society still perpetuates the myths and stereotypical views about women's primary role

as wives and mothers in the post-independent Africa.[19] Such knowledge when used critically can help us to deconstruct what we know about women. By deconstructing and problematizing the stereotypes, we begin to see new spaces that enable us to look more critically at the impact of those stereotypes on women's lives.

I identify and discuss three important socio/historical contexts: the African traditions/culture, the colonial, and the contemporary or post-colonial. I look at the discourses that reside in these contexts in order to explicate ideological underpinnings that inform such discourses. Examine the historical and social contexts of domesticity from the perspectives of the African tradition, colonial, and post colonial discourses laid the groundwork for understanding and analyzing women's diverse experiences. It involved dealing with cultural and social issues that sometimes seemed so similar and yet affected women differently. Often such cultural and social details are obscured if, and when, women's experiences are generalized.

The discourses on African women's domesticity have been influenced differently by these three perspectives. The African culture and traditions influenced the discourse on domesticity through tautology of customs and traditions. In the same vein, the contemporary or post-colonial government's impact is made through policies and regulations. While these two social structures are distinct and different, their discourses on women's domesticity tend to be mutually enhancing and mutually supportive by implication or default.[20] The colonial influence clashed with indiginous cultures particularly on issues such as domesticity and created problematic cultural struggles that still persist today.[21]

Discourses constitute all that is written or spoken and are historically specific and socially situated, signifying practices embedded into the rhetoric of what people say and do. Therefore, I use the term discourse to mean both cultural conversations and informal engagements in everyday lives. These everyday conversational and cultural engagements are powerful in that the ensuing discourses eventually translate into policies and practices relating to women's domesticity.[22] Discourses can also include government policy documents (in areas such as education) that influence the perceptions and practices relating to education for women. Discourses, therefore, are much more than ways of talking; they take a

"form of power game"[23] played through gender ideologies—like domesticity. They embed themselves in politically discursive ways to shape society's view on various groups, including women. Normally, when discourses enter into a discursive relationship with social structures, they infiltrate systems and get reinforced by key institutional sites, including that of education.[24]

By analyzing discourses on women and education, I show how these three perspectives (African tradition, colonial and post-colonial) dictate the societal asssumptions of such issues as motherhood and domesticity. Such assumptions affect the women's pursuit of, and access to, education. Tensions emanating from oppositional discourses are not only important in revealing contradictory demands on women's lives. They help chart important defining moments of change and transformation in women's lives.

Defining moments are what Denzin,[25] calls "epiphanic moments."[26] These moments uncover the hidden and the unconscious worlds of gendered experiences and are experienced when women encounter contradictory events or demands. Several epiphanic moments have been identified in my respondents' lives to illuminate very deep and subtle cultural stereotypes on issues pertaining to domesticity. In teasing out layers of narrative, the cultural consciousness of the tensions of epiphanic moments, the underlying dominant influence or ideology over the life of each respondent is revealed, thus making the process very empowering. Specific epiphanic moments as narrated by individual women will be discussed in the narrative interpretation chapters.

My argument in this study is that domesticity has made education for African women at home and abroad problematic. I also argue that the way in which African women respond to schooling, for example, is different from women in the West because of their different gendered and cultural experiences. The respondents' life-history narratives, therefore, offer a unique chance to look into the gendered views regarding their expected roles as mothers and wives, and how they challenged these gendered views through their decision to go back to school.

In the following section, I highlight African tradition, colonialism, and the post-colonial or the post independence perspectives, in order to interrogate the tensions between domesticity[27] and education. I show how

the choices African women make translate into contradictory demands on their lives. First I offer background on African traditions and culture as the basis for social relations within which domesticity is defined, enacted and affirmed.

AFRICAN TRADITIONS AND CULTURE

Culture is one of the concepts that elude clear and definite definitions.[28] However, culture is generally defined by many anthropologists as that which embodies moral, ethical and aesthetic values that form the basis of a people's identity and their sense of particularity.[29] My heightened sensitivity to the "danger" of trying to define culture in absolute terms comes as a result of my personal discussion with Linda Nicholson on cultural relativism during the writing of this book.[30]

A contemporary feminist postmodernist, Linda Nicholson helped me articulate how, for example, essentializing and idealizing culture tends to make it static. One danger of homogenizing African cultures relative to the women in my study was the possibility of obscuring the fact that these women were affected differently by their respective African cultures. Even in very similar circumstances, cultures tend to affect individuals differently based on how the cultural attributes are interpreted and given meaning. Thus, in reference to my study on African women (from different countries in Africa) I have hesitated wrapping "African cultures" into one African culture because African cultures are not homogeneous. However, as much as I understood that there was no one African culture, it was problematic for me to emphasize the cultural diversity of the women in the study, and at the same time show how they are marginalized as a group by the African culture. How would I problematize African culture as basis of women's subordination without essentializing it as a category of scrutiny and analysis? Drawing from Munro[31] "I paradoxically seek to create and disrupt"[32] the essentialized notion of the African culture. My intent in essentializing African culture is to show that: 1) African cultural norms, customs and values are produced and reproduced through culturally legitimized and validated local knowledge or discourse when people interact within material conditions, ideological production, and representations of that condition or discourse, and 2) the tradi-

tional values and norms, wrapped up as givens within the ideology of domesticity in the African culture have created a negative impact on women's lives. Theorizing the influence of African culture from this perspective has allowed me to show that domesticity, in this context, becomes the major value-shaping factor in the female gender socialization across cultures. As a result of this socialization process, the consciously or unconsciously internalized values guide how women function in various gender roles. And, because these values are internalized without questioning or exploring their origin, they represent the "truth" about the meaning of cultural practices including domesticity or motherhood.

The perspective of African traditions as "givens" is an important point of departure for this study for two major reasons: First, it shows that the magnitude of the cultural grip on the unexamined lives of women is critical to understanding African women. Second, it problematizes the notion that culture, values, and norms are static ideals and that they are neither changeable nor negotiable. I focus on how the women in the study realized that they were not only affected by their cultures, but that they were also affecting the culture by simultaneously being creators, transformers, contesters, and reproducers of old cultural practices and ideological values. Consequently, domesticity must be shown as produced within social relations rather than simply a product (a value) that exists in society and shapes or/and constrains women's status. I argue that this perspective engenders a transformative possibility through women's realization that they can confront cultural beliefs that have defined them. They can contest and recreate their understanding about what it means to be a mother, a wife, and an educated woman within the African culture.

In this study, I looked at the similarities of what women understood as culture or cultural values in their narratives and used these similarities as the basis of using the term "African culture." In echoing Linda Nicholson as quoted by Gieger: "We acknowledge that our claims about women are not based on some given reality but emerge out of [their] own history and culture."[33] Therefore, traditions, norms, and customs—which I have used interchangeably—express the rules and regulations that govern specific cultural practices and have represented the women's views about what culture has meant to them.

In relation to the cultural expectations of African women, the decision to return to school is not an easy task for any African woman. Rather, it is a complex decision making process "full of mixed feelings, ambivalence and psychological conflicts within the woman herself, the family, and even close relatives."[34] Female socialization process within the context of African culture implicitly discourages women from aspiring to compete for status or high rank in career hierarchies.[35] African society primarily defines women in relation to reproductive roles. Therefore, the cultural construction of womanhood is fundamentally based on the concept of motherhood. Because motherhood is primarily a feminine role of responsibility to the family, African female cultural socialization and expectations never strayed far beyond the confines of familial obligations. In her book, *Women of Africa: Roots of Oppression*, Cutrufelli, argues that because of the "hardening attitude in traditional societies toward feminine role; the social duty of motherhood became more binding, even a kind of social obsession and, in allowing no option, a sentence against the women."[36] In this context, for a woman to put aside gendered cultural expectations and family responsibilities in favor of returning to school is not only antithetical to socially assigned roles, but women who do so are severely ostracized.

Colonial Influence

According to Afshar, "the colonial administrators and missionaries brought with them patriarchal conceptions of appropriate social roles for women."[37] One such concept endorsed by the missionaries was women's domesticity. Christian missionaries taught wives of African converts to be "good" mothers through simple courses like housewifery, sewing and hygiene, while they trained the men for paid labor as clerks, carpenters and teachers of catechism.[38] Although domesticity, as a patriarchal construction, was evident in the African traditional context as well, the specifics of what domesticity entailed within the African traditional and colonial contexts were clearly different and varied. For example, although their roles as wives and mothers were defined as domestic, African women, within the African traditional patriarchal context, were neither confined necessarily to the specifics of monogamous homes nor were they completely dependent on their husbands. Through their collective efforts

as mothers, wives, and tillers of land, African women enjoyed a certain amount of spatial freedom and economic independence. They took advantage of the established family-based economy and land tenure arrangements and usage rights established within the African household set-up. However, this freedom varied from one tribe to another.[39] What was important, though, was that the women understood their rights and roles within an explicit and familiar cultural space compared to what the colonialists presented.

The colonial definition of femaleness and domesticity reflected a European gendered division of labor that was clearly different from the African tradition. Domesticity within the colonial context engendered a restricted definition to include whiteness, modernity (read unprimitive), and economic dependency on waged men within a monogamous household. The colonial process of reconstructing the traditional familial constellation and wage-earning traditions had a significant impact on African women's economic activities and social options. Colonial definitions of domesticity, for example, not only restricted African women's spatial mobility but also marginalized and dislocated them economically and politically by stripping off their productive rights within an indigenous social order already distorted and weakened under colonial rule.[40] Further, while the African traditional definition of domesticity allowed women a certain amount of physical and spatial freedom within the context of the extended household, as mentioned before, the colonial notion of domesticity limited this spatial boundary to a single, monogamous household. Colonization also required women and girls to be away from home for extended periods of time for formal education and training because these opportunities were available only in the mission schools. Colonialism, as mentioned earlier, resulted in the clash between indigenous cultures and the European culture.

It was evident that changes in the practices and meanings of domesticity were played out differently in the lives of different women. To some, the colonial version of domesticity was an outright intrusion into their cultural beliefs and practices and, therefore, an infringement on their rights to function in their roles as women. To others, the colonial notion of domesticity promised *maendeleo*[41]—a civilized way of life—as depicted by the lifestyles of the wives of the missionaries. However, the *maen-*

deleo called for different lifestyle dynamics that were not only unfamiliar to the African women but were incompatible with African lifestyle. For example, for African women to be "civilized," they had to be emancipated from the smoky kitchens and unhealthy, crowded and unkept African grass-thatch-roofed homesteads to the modern stone houses with cemented floor. This type of house continues to be associated with modernity. The house was considered a symbol of civilization not because of its appropriateness to the lives of African women, but because of the statement it made about modernity. This transplantation from traditional to modern ignored the practical issues involved in juggling the demands on how women ran their households within the two incompatible lifestyles.

Without risking the glorification of the African traditional family set-up, the colonial concept of family failed to account for the traditional structures of extended families and a more communal household where the shared power dynamics sustained such structures. Colonial practices and concepts contradicted African patriarchal institutions, thereby creating tensions and divisions between those who held onto the traditions and those who converted. But, even for those who opted for "civilization," the colonial notions of domesticity did not address racial dynamics. For example, there were no provisions made to accept as equals or as "white," the Africans who had converted because "whiteness" as a racial capital was the colonizing factor. As a result, a new category of displaced hybrid individuals stereotyped as "Athungu Airu"[42] or "Black Europeans" emerged. Given the tension between the traditional family system governed by the traditional norms and the "modern" system based on the legacy of colonialism, colonial and African ideological constructions of concepts like motherhood, domesticity, and modernization meant and continued to mean different things to different people including women.

Post-Colonial Discourse on Domesticity

Domesticity in the post-colonial African societies has undergone numerous changes. As mentioned before, since the onset of colonialism, traditional African households have been in a state of flux as they respond to economic, ideological and other forms of transformation.[43] The extended African familial arrangement, for example, has been disrupted by people, mainly men, moving to the cities to look for jobs. Conjugal relationships

have also been transformed from predominantly polygamous relationships to monogamous, reflecting the nuclear familial arrangement of the Western culture. But even with all these changes, the African traditional image of women as mothers and wives remains very strong.[44] Women as mothers and wives continue to bear the burden of domestic responsibilities, and the traditional African values attached to the concept of motherhood continue to dominate the socialization process. Presently, it is not uncommon to see girls being married off in their early teens or to see young girls dropping out of school to allow the family's meager resources to be used to pay for a boy's education.[45] As a result, very few girls complete primary education. Girls continue to work alongside their mothers, engaging in domestic chores at the expense of education.

Despite additional burdens that go with the roles of motherhood, many women in Africa continue to see motherhood as their source of purpose and fulfilment.[46] The pre-colonial and colonial gendered division of labor is still reflected in the present post-colonial Africa and continues to marginalize women within the private domestic sphere. Although a greater number of African women, particularly in the cities, participate in paid labor outside the home, they also continue to take on most domestic responsibilities. As a result, gender inequalities and assumptions about the appropriate roles for women in Africa continue to reflect the historical and cultural biases of domesticity. Therefore, the more things have changed in the present-day Africa, the more they have remained the same in the lives of African women. Conflicting social, economic and structural patterns that have marginalized women over the years still persist in the present post-colonial Africa.

There also seems to emerge a different type of "obsession with culture" in contemporary Africa. I see it as a cultural paradox. The more they are fearful of Western cultureal hegemony and protective of their cultural values, the more they feel protective about their cultural heritage because of the fear of Western cultural hegemony.[47] This fear is mostly expressed through cultural obsession with the idea that motherhood and domesticity are central to women's identity and, therefore, must be protected and possive. The fear is augmented when women choose to study in a foreign country and has been used to another strategy to . For example, it is not uncommon to find that many women choose not to further their studies for fear of the consequences of failed marriage and motherhood. Tausi speaks

openly about her conflicts and worries when she says that her "greatest fear is that I will be alone. That I will have no marriage . . .that is something I will have to deal with." As Kiluva-Ndunda rightly puts it:

> In the formulation of educational policies, gender issues are framed in ways that confine women's agency to the private sphere and fail to challenge the gender and power factors that impede women's agency in the public sphere alongside men.[48]

However, even within the private sphere, such as family, women's agency is curtailed because post-colonial African governments' social and legal structures in most poet-colonial African cultures reinforce cultural norms by sanctioning the African patriarchal customary law to function along the judicial laws.[49] It follows, therefore, that women like Tausi who pursue higher education abroad have to deal with the consequences of their decisions on a private and personal level because there is no government policy that addresses specific educational and familial issues concerning women who choose to go abroad.

In line with the above discussion, rethinking domesticity of the intersection of traditional, colonial and post-colonial perspectives requires a serious review of the impact of the different patriarchal demands of domesticity on the lives of women. Such differences in patriarchal definitions of domesticity point to the fact that patriarchy or patriarchies cannot be assumed to mean the same thing universally and cross-culturally.[50] Any attempt to see colonial and African patriarchies as monolithic forms of oppression on women, or to assume that African women are affected by "patriarchy" in similar ways and through similar strategies and structures, erases the fact that these different patriarchies have always exerted and continue to exert multiple forms of oppression on women.

Similarly, in the light of the above discussion, it is not surprising that crucial features of culturally acceptable motherhood have roots in African precepts as well as colonial ideals.[51] Therefore, African women's domesticity is culturally and socially constructed by distinctly gendered, racialized and ethnicized tribal assignments and institutionalized by the traditional and post-colonial power structures in the African society. Such institutionalization illuminates how traditional, historical, colonial, and

post-colonial conventions intersect to become powerful ideological tools for domination and marginalization of women. What makes African women's responses to domesticity and education different from Western women's, for example, is that such responses are predicated upon the influence of gender and also the tribal, ethnic, national, colonial and post-colonial patriarchal expectations. In researching African women, therefore, it is important to provide insights into how they have confronted and continue to confront these dilemmas.

This complex interplay of indigenous cultural expectations, the colonial anticipations, and present-day demands of domesticity create tensions about what it means to be a woman within these opposing and contradictory realms. Caught between the patriarchal construction of domesticity and education within the African traditional and the colonial (modernity)[52] and the post-colonial contexts is the educated African woman. She is not only located within this web of cultural struggles, but she is displaced as well.

In positioning domesticity and education in opposition to each other, I do not wish to dichotomize them as separate entities of incompatibility[53] affecting women at different times and locations. Rather, I do so to reveal and assert the oppositional pull, the intersectionality,[54] and the ubiquitousness of these forms of incompatibility acting simultaneously to affect the understanind of African women at different times and location in their lives. In addition, to think that African women's predicaments are only confined to the choices they make between domesticity and formal education is too simplistic. Dichotomizing domesticity and education and purporting the need to choose one over the other, obscures the "integrativeness" and "connectedness" of the two concepts, and the role they play in shaping women's experiences and in defining who they are and what they do everyday as women.

In her book entitled *Weaving Work and Motherhood*, Anita Garey studied dominant cultural construction of motherhood and work in the United States. She contends that "choosing between" motherhood and work implied that "choosing both" is not an option. Similarly, African society's inability to conceptualize the integration of domesticity and education as possible and desirable has resulted in frustrations for many educated women in Africa. Many educated African women are "seen as simultaneously less dedicated to their families and more dedicated to their careers; more selfish and less sensitive to the needs of others."[55]

This has been a traditional problem that both Western and African women experience when they have tried to "weave" together two supposedly opposing arenas, and these struggles are relegated to the personal realm of life. In defining these struggles as "personal struggles," women are expected to deal with them privately. Divorcing the everyday women's experiences from the larger social and economic relations has exonerated society from the responsibility of allowing women's lives and issues to be formulated as social issues and problems requiring collective social solutions. This privatization of women's experiences has proved detrimental to the status of women and women's education in Africa.

I argue, therefore, that as long as education continues to be the determining factor for social and economic success, as long as the discourse on women's education and policy continue to be based on the societal assumptions of the incompatibility between domesticity and education, and as long as women who opt to pursue higher education are ostracized by society for violating or transcending the confines of domesticity, most women in Africa (both educated and uneducated) will continue to experience marginalization.

Therefore, it is evident that the factors that impinge upon women's access to education are complex and pernicious. This study brings to the fore the dynamics of this complex social context, and then situates women's conflicted subjective lived experiences within these dynamics in order to substantively address the status of women and women's education in Africa as major social issues requiring societally based solutions. Privileging women's narrative, as this study does, is one way to allow women to articulate what they can be, and to do so from their own perspective.

Purpose of this Research: Personal Perspectives

The idea to study the tension between domesticity and education emerged out of conflicts and contradictions I experienced before and after I made the decision to leave my family in Africa and come to the United States to pursue further education. According to Fonow and Cook, cited by Bloom, "The questions the researcher has about her own life based on her situation at hand are valid questions for framing the research project."[56] I realized that

the decisions I made, though empowering, were conflicted for various reasons. First, I had been socialized to value my duties as a mother and wife so much so that I almost felt as if life would not go on for my family without me. I had not foreseen any major problems created by my absence, because, by virtue of his paternity, social standing, and economic ability, my husband was willing and able to take charge of the family. However, my culture has never considered the daily activities of looking after the family as primary roles of fatherhood. Second, despite my position as a mother, I was also a university lecturer, and the institution I worked for required that I measure up to certain academic expectations just like anybody else.

Within this complex situation, I recognized both societal and familial forces working on my position guided by the patriarchal power relations that defined my identities as a woman, a mother, and a wife. In opposition were other liberatory forces that defined me as a self-actualized, educated, and professional woman. Consequently, I started to question the nature of my own decisions, the legitimacy of social structures and various values and expectations within my lived experience. I experienced an identity crisis. This ambiguity and nexus of ambivalent thoughts bothered me. Feminist researchers acknowledge an issue that concerns them and then focus on the issue for an in-depth study.[57] I accepted the meaningfulness of this assertion, and it became a strong impetus for determining the topic of this book.

For this study, I chose three African women who pursued higher education in the United States for various reasons. First, having lived with the tensions between domesticity and education, the respondents' lives epitomized this contradiction. I used the narrative experiences of these three women as important sites for exploring the tensions between these two constructs. Second, this category of women is underresearched. Besides the works of Bhalalusesa,[58] Otieno,[59] and Okeke,[60] which all expressed the need for more research on African women in higher education, there is remarkably very little research on the problematic experiences of African women who have defied norms of domesticity to study abroad. Additionally, with the current advent of globalization, feminist scholars worldwide have focused their attention on how women from different parts of the world grapple with constraints that hinder their full participation in political, social and economic development. Consequently, this feminist life history study was committed to analyzing African women's lives as they experienced tensions

between domesticity and education, and has provided useful insights into such constraints. This study specifically problematized domesticity as a social and cultural construct in order to illuminate the social/cultural, political and economic factors that inhibit and complicate African women's access to education in Africa and abroad.

This study addresses the current need for cultural diversity and greater "inclusivity" within feminist discourses and will contribute to feminist and international scholarship as an added voice calling for increased feminist scholarship on women in Africa and the African Diaspora.[61] Finally, having identified myself as an African woman graduate student, studying "within-group"[62] allowed me to study the problems of my own situation. The shared experiences with the three women provided the "lenses" through which to study the tensions between domesticity and education that I experienced in my pursuit of higher education. By researching within, I was also able to explore various feminist methodological issues that were of interest to me. For example, I wanted to blur the boundaries between the researcher and the researched and to nullify the "conventional reproduction of status quo associated with knowledge production through unequal power relations in which the researcher wields a certain amount of power over the researched."[63] I believe this sentiment was fulfilled in this study as it became a reflection of my endeavor to generate knowledge and information in a more egalitarian relationship between the respondents and myself. It has been argued by most feminists that the process through which knowledge about women has been produced has traditionally been guided by the questions derived from men's interests and male-dominated institutions.[64] Feminist life history methodology provides an avenue through which the questions women have about their lives and experiences can be illuminated and addressed.

GAINING OURSELVES

I envisioned this study as a project that would allow me to not only address important social issues, but to also explore my yearnings, my meaning-making, and my thought processes. Challenged by my own ambivalence, I see my role as a "auto/ethnographical-researcher"[65] as a

way to discover myself through the life stories of my women respondents. And because my respondents and I agreed to be in this journey of self-exploration together, I believe that:

if the stories inform and redirect our lives then [our] efforts [will not] be in vain . . . if what [we say] frees us in some small way, then we [will] have achieved much more than merely recording history. We will have gained ourselves.[66]

I envision the metaphoric process of "gaining ourselves" unfolding from the concepts of "loss" and "gain" which are central to these women's stories. Gain presupposes loss. Most of these women have lost their cultural ties by violating cultural definition of motherhood and domesticity; they have lost the warmth of their families as well as the power and privileges accruing from their social locations as wives and mothers; they have lost the comfort of the familiar home and country by immigrating abroad; and are threatened with the loss of their own sense of identity as individuals and as women due to their dislocation. This study hopes to make up for the losses the women have suffered by: 1) acknowledging and naming the losses, 2) narrativizing[67] women's experiences of becoming educated, 3) defining new ways of defining themselves and, 4) creating a social and a shared consciousness.

Acknowledging and Naming the Losses

The first step in making up for the losses as a result of defying norms of domesticity is for the women to acknowledge and confront these losses and pain. They acknowledge the pain through the stories they tell about who they are, what it has taken them to be where they are, the strengths upon which they have drawn and what they have risked to do. I see the process of gaining themselves culminating into a form of activism, empowerment, and agency. Feminism allows us to begin to recognize how designating parts of our lives as public and others private has shielded power used against women and prevented us from exerting our own power.[68]

Narrativizing Women's Experiences of Becoming Educated

Narratives of these women's lived experiences pertaining to obstacles, ambivalence, and nuances stemming from the decisions to come to the United States will provide insights into what it means to be educated, progressive African women. It is through the stories we tell about ourselves, or stories that others tell about us, that we find identity and meaning. As Munro also rightly puts it, women's narrative becomes a "generative space for understanding not only the complexities of women's lives but also how women construct [and deconstruct] a gendered self."[69]

Putting Women's Experiences at the Center

"Gaining ourselves" has involved exploration and documentation of women's knowledge and insights. Through the process of reflection and disclosure, women's life experiences are put at the center where biases and unique assumptions are made explicit. Placing women at the center also involves understanding and amplifying their experiences and illuminating how, indeed, women who choose to further their education are often marginalized through alienation and exclusion from the mainstream society. In the past, the effects of historically structured forces (colonialism, post-colonialism, patriarchy/ies) have had an enormous influence on the ways that researchers have, over time, defined poor, uneducated African women as sites and objects of research. Often, the African women who were educated were not perceived as marginalized because they no not fit the stereotype. By reasserting the marginality of this group of women while simultaneously placing them at the center, this study challenges and problematizes the construction as well as the definition of marginality, thereby creating space for African women to begin gaining and defining themselves in new ways.

Creating Social and Shared Consciousness

The process of the three African women "gaining themselves," begins with a deliberate facilitation of both collective and individual processes of growth and self-awareness through their participation in this study. Based on their common struggle for education as well as other experiences that are important to them, unique knowledge and insights have been generated about African women. Past attempts to universalize

Western women's knowledge as representative of all women, as was the case with the concept of "Global sisterhood,"[70] advanced by Western feminists have worked to misrepresent African women. Universalization of women and women's issues denies and obscures the uniqueness of women in terms of how they perceive and experience personal and collective growth. Because they experience different cultural constraints compared to their counterpartsin the West, African women who prefer higher education observe that everyone's professional trajectories as a result of the choice they make. Any study, therefore, that ignores the centrality of, and sensitivity to, cultural context within which African women operate is suspect and can only remain suggestive of the realities of African women.[71] This study provides an opportunity for activism and agency through illuminating the cultural realities that inhibit African women from realizing their potential. Through creating a social and shared consciousness, the individual women's problems become shared problems and women begin to envision together, a world full of possibilities. Through the social and shared consciousness the women begin to recognize that within their collective and individual consciousness lies an inner strength and awakening that is capable of altering their marginalized sense of self. It is at that point, when women become aware of this inner strength, that they are able to see possibilities beyond domesticity, beyond motherhood, and beyond cultural constraints. It is at that point that they truly experience the beauty in "gaining themselves."

OVERVIEW OF THE BOOK

In this study I look at the experiences of African women pursuing higher education in the United States. Through the women's stories, I highlight the personal and societal tensions African women experience in seeking higher education abroad. I interrogate how African tradition, colonial, and postcolonial definitions of motherhood and domesticity have worked to constrain such efforts. I explore the tensions between domesticity and education in women's lives and how the women have negotiated their positions and pushed for opportunities.

This book is organized into seven chapters. Chapter One serves as the introduction to the study as a whole. Chapter Two, which covers the methodology, is divided into two sections. In the first section, I discuss feminist narrative and life history methodological theory. I discuss in detail the importance of using feminist narrative and life history methodology to study African women. The second part of the methodology section describes the research process. In addition, I explain the interpretive framework I used to make meaning of the women's narratives. Chapters Three, Four, and Five constitute the interpretation sections. Tausi's story in Chapter Three focuses on narratives about her life experiences using the metaphor of a "movie." Although I interviewed Tausi in the United States, her narratives mainly reflect on her life and the circumstances that led her to seek higher education in the United States. Being in the U.S. provided space and time for her to reflect on her life. Chapter Four explores Tenji's narratives. Although she draws extensively from her exposure in the United States, her narratives mainly focus on the experiences after returning home with a Ph.D. in Regional Planning. Her narratives are mainly about her transitional struggles as she tried to fit back into the society.

Chapter Five presents Tamara's narratives. Tamara came to the United States much earlier than Tenji and Tausi and later went back to Africa. Her narratives begin with an acknowledgement of her ability to navigate the troubled waters within the university context in Africa, which neither recognizes nor rewards women with similar qualification and experience, as it does men. The three women's narratives seem to piece together into a bigger picture and a wider timeline revealing the reality of painful but empowering trajectories that African women took in pursuit of higher education.

In Chapter Six, I reflect on how, as an African feminist researcher, I think about feminist methodology and its implications for studying African women. Based on the argument that Western theoretical framework is not always inclusive nor adequate in itself for interpreting African women's lives, I propose and articulate a "frameless/framework as an alternative theoretical approach to studying African women. The frameless/framework is envisioned as capable of illuminating the uniqueness of African women contextual experiences in their everyday lives.

I conclude Chapter Seven by writing letters and a memorandum to: 1) the heads of governments in Africa, 2) presidents of universities in

Africa and, 3) the younger generation of African women. In the spirit of activism, I have translated the women's stories into useful information for government and university policy-changes and for encouraging the younger generation of women of Africa. The memorandum to the heads of governments and the presidents of the universities consist of recommendations for policy changes on women issues specific to their institutions. My commitment to activism is reaffirmed, further, as I discuss in the next section, the importance of using feminist narrative life-history methodology.

Notes

1 Abagi and Wamahiu, 1995; FAWE, 1996; Kaziboni, 2000
2 1991
3 p. 847
4 Mbilinyi & Meena, 1991; Kaziboni, 2000; F.A.W.E., 1996.
5. 1991.
6. 2001.
7. p. ix.
8. Kiluva-Ndunda, 2001, p. ix.
9. Tausi is a pseudonym of the first of my women respondents. I have used pseudonyms to ensure confidentiality of the respondents and the institutions they attended.
10. Tenji is the pseudonum of the second respondent.
11. Tamara is a pseudonym of the third respondent.
12. Kaziboni, 200; Kiluva-Ndunda, 2001; Otieno, 1998.
13. Mwangi, 1992.
14. L. Nicholson, personal discussion, march 6, 2002.
15. Garey, 1999.
16. Mwangi, 1992.
17. Abagi, 1995; Abagi and Wamahiu, 1995; Kaziboni, 2000; Kenyatta, 1962.
18. Afshar, 1987.
19. Kaziboni, 2000.
20. Kiluva-Ndunda, 2001; Kelly & Elliot, 1982; Hay & Stitchter, 1995.
21. Berger and White, 1999; FAWE, 1996; Kenyatta, 1962.
22. Kiluva-Ndunda, 2001.

23. Rosenau, 1992, p. 111.
24. Narayan, 2001. Uma Narayan's critique of cultural and post-colonial constructions of Third World women and cultures suggest that a historical attentive and politically astute understanding can help avoid totalizing, reifying and problematic pictures of Western culture and of specific Third Wold cultures.
25. 1997.
26. p. 208.
27. Ideology that relegates women and women's roles to domestic (or private) sphere.
28. Clifford and Marcus, 1986; Nicholson, 2001 (unpublished manuscript); Narayan, 1997.
29. Thiong'o, 1994. Although I use Thiong'o's definition of culture, I do not agree with his beliefs about culture and its impact on African women's lives. Thiong'o tends to glorify culture as a basis of fighting neo-colonialism and ignores the negative impact that culture or traditions might have on women's lives and their status in society.
30. Personal communication, March 6, 2002.
31. 1998.
32. p. 1.
33. 1999, p. 32.
34. Bhalalusesa, 1998, p. 22.
35. Bhalalusesa, 1998.
36. 1982, p. 2.
37. 1987, p. 15.
38. Chambers, 1999; Mwangi 1992. Defined as instruction by a series of questions and answers on the religious doctrines of the Christian church, p. 246.
39. Berger & White, 1999.
40. Berger & White, 1999.
41. *Maendeleo* is a Kiswahili word translated to mean "development." This tern was used as a slogan by the British colonialists to get the African "natives" to accept modernization. Specifically, *maendeleo* represented a program for native women to be taught good housekeeping and housewifery skills by the wives of the colonial masters. Today, the word is still associated with modernization, although the emphasis now is more geared towards integrating women in development. This concept is still problematic today as it was then because it implies that women are not part of the national development programs but need to be integrated.

42. This term was used to skeptically refer to those who had taken the ways of the White man (religion and education) but could not change the color of their skin. Unfortunately, the same sentiments are inferred about women who become educated and, as a result, neither fit into the cultural fold nor become fully assimilated into being "White."
43. Hay and Stichter 1995.
44. Kiluva-Ndunda, 2001.
45. F.A.W.E.,
46. Kiluva-Ndunda, 2001.
47. Bennaars, 1995.
48. 2001, p. 156.
49. Stamp, 1986; Aubrey, 2001.
50. Mohanty, 1991.
51. Litt, 2000.
52. "Modernity" is hereby held in opposition with "tradition" within the colonial hegemonic politics of difference. In this context, it used to mean civilization (read Westernization) as opposed to primitive (read indigenous traditions).
53. I use this term cautiously because as much as these systems are perceived as incompatibles, women's lives are indicative of how they are constantly "weaving" (Garey, 1999) these incompatibles together into intricate patterns that describe their everyday life experiences.
54. Collins, 1998.
55. Garey, 1999, p. 6.
56. Fonow and Cook, 1991, Bloom, 1998, p. 147.
57. Reinharz, 1992.
58. 1998.
59. 1998.
60. 1996.
61. African Diaspora refers to the peoples of African descent living outside of the African continent. The concept of Diaspora originated in the dispersion of Jews around the world. Diaspora as a concept has been used in feminist discourses to theorize displacement.
62. Mama, 1995, p. 67.
63. Mama, 1995.
64. Harding, 1987.
65. Ellington, 1998; Denzin and Lincoln, 2000; Tierney, 1998.
66. Etter-Lewis, 1991, p. 127.

67. By using the term "narrativizing," which derives from the term "narratology," I describe a process that involves much more than a simple process or narration. I draw from Bloom's (1998) discussion on the importance of engaging Feminist Narratology in dealing with women's storied lives. Bloom (1998) lets us know the danger in women creating unconsciously, stories about their experiences in a narrative form that reflects the conventional dominant masculinist mode of thinking or "master-script. Feminist narratologists, therefore, expose the working of the master-script in women's lives by encouraging women to "narrativize" or actively narrate their real life stories without masking their feelings and emotions. Narrativizing process becomes a means through which women gain agency, strength, and encouragement through self-knowledge and self-representation. Narrativizing, in feminist perspective, becomes an alternative narrative strategy for "creating narrative texts that allow women's gendered perspectives and subjectivities to be represented" (Bloom, 1998, p. 69).

68. Walker, 1995.

69. Stivers, 1995; Munro, 1998, p. 50.

70. Nnaemeka, 1998.

71. Kelly and Elliott, 1982.

Chapter Two

FEMINIST NARRATIVE AND LIFE-HISTORY METHODOLOGY

METHODOLOGICAL THEORY

The process of choosing or deciding on what methodology to use in carrying out research is not an easy task. It requires the thorough understanding and conviction of the researcher, not only about the nature and the goals of the research, but also the researcher's position regarding research as a process or a means of accomplishing those goals. As Bloom states, "methodology is deeply rooted in and should be consistent with the epistemological beliefs that a researcher brings to her inquiry."[1] Epistemological beliefs address questions like: What is knowledge? How is knowledge constructed and who can construct knowledge?

For me, this process involved intense self-searching moments about who I am, what my values are, and how I understand the world around me. This process also involved a thorough understanding of the "theories or perspectives that inform the production of particular kind of research and justify it in terms of its knowledge making."[2] I believe this moment of searching for a methodology is important because, according to Schawndt:

We conduct inquiry via a particular paradigm because it embodies assumptions about the world that we believe and val-

ues that we hold, and because we hold those assumptions and values, we conduct inquiry according to the precepts of that paradigm.[3]

For me, the process of searching for a method crystallized as I began asserting the assumptions I brought to this study based on the ideals of Western feminism. I have been greatly influenced by Western feminism after having embraced and learned about it in graduate school. Consequently, when it came time to do the fieldwork and analysis for this study, I drew from this body of literature that I had been studying. In this section, I discuss and reveal how feminist methodological theory and process has informed the production of this research.

McDonald cited in Aina defines feminism as "encompass[ing] both a political and an academic or theoretical stance, both stressing the lived experiences and actions of women's lives as crucial to any understanding of the social aspect of humanity"[4] Feminism offers "a critique of and a remedy [through activism] for the prevailing male ideology which influences the lives, the ideas and the physical, emotional . . . well-being of women"[5] In discussing feminism as political activism, Chris Weedon cited in Mama states:

> Starting from the politics of the personal, in which women's subjectivities and experiences of everyday life become the site of the redefinition of patriarchal meanings and values and of resistance to them, feminism generates new theoretical perspectives from which the dominant can be criticized and new possibilities envisaged.[6]

Feminism as political activism, therefore, calls for the careful and critical work of unraveling the interwoven complexities of gendered meanings and social structures in order to rethink the premises on which the contemporary patriarchal culture is based.[7] The most effective way of trying to unravel the complexities of experiences and meanings of women's lives is by engaging in feminist research. While I argue that any study that addresses women's lives and experiences lends itself to feminism, I am also aware that not all studies about women are feminist. What then is feminist research?

32

First, feminist research is based on the premise that reality and knowledge are socially situated and constructed[8] and that dominant social institutions and attitudes are the basis for women's subordinated position in society. The feminist critique of the social construction of reality enables us to question traditional/cultural realities and practices and the knowledge that has been superimposed on us through socialization. Specifically, my study of African women's experiences illuminates and problematizes the social/cultural, political and economic factors that inhibit and complicate their access to higher education by identifying gaps and tensions in their lives. Secondly, feminist research is characterized by an emphasis on women's lived experiences and the significance of their everyday lives.[9] By putting women at the center of the analysis, they become not only subjects (rather than objects) of study, but also co-creators of knowledge. Finally, feminist research is transformative and has a strong political and ideological commitment toward changing the positions of women and, therefore, changing the society.[10]

In order for feminist research to be transformative, to emphasize women's lived experience, and to problematize social/cultural factors, a methodology that reflects these feminist ideals is necessary. According to Harding,[11] a methodology constitutes methods or techniques of data collection as well as theory and analysis of how research does or should proceed. While many feminist theorists[12] have argued that there are no feminist methods *per se*, and that feminist research can use the same techniques or methods of data collection used in other forms of research, a strong feminist methodological discourse has emerged from feminist critiques and innovations raising issues about doing feminist research on and for women.[13] This discourse addresses methodological and ethical issues that reflect particular feminist concerns like the researcher/researched relationship, the role of the researcher and the process or practice of carrying out feminist research. As a result of these concerns, for example, feminist methodology advocates the use of various approaches or strategies of investigation and data collection in ways that are sensitive to women's cultural contexts,[14] their positionality, and intersectionality,[15] and the multiple and subjective nature of their identities.[16]

What is distinctive about feminist methodology (and discourse) is that it engages theory-building from varied feminist approaches and through reflective concerns of issues raised by feminist researchers and participants.

Feminist methodology does not, therefore, always begin with a theory constituting prescriptive procedures to be strictly followed. Rather, it presents and encourages the development of a distinctive body of writing, thinking and research practice[17] or what Lather[18] calls "research as praxis" to create a well-supported, theoretical understanding of the interplay between context, theory, and practice. This interplay of context, theory, and practice enables feminist researchers to scrutinize, analyze and look for patterns and explanations out of which feminist theories and perspectives for doing research on women emerge. This form of research practice aims at empowering women by building theory (or theories) grounded in specific real life experiences that are important and meaningful to them. My theory building process about the experiences of African women evolves out of the personal narratives that constitute the bulk of the data used for this study.

In considering suitable feminist methodological approaches or strategies to use to investigate and illuminate women's lives, I identified life history and narrative approaches as primary tools of research. Life history research is comprised of contextually situated, in-depth accounts of personal life, while narratives are "the linguistic form that preserves the complexity of human actions."[19]

Because of their contextual situatedness, life histories are important in capturing cultural contexts and linguistic forms of narratives that portray the complexity of African women's lives. As a result, the subjective nature of women's identities as well as their voices can be heard. However, the terms life history and narratives have been used quite differently by different people. Some use the terms separately, while others use them interchangeably. Hatch and Wisniewski's book entitled *Life History and Narratives*,[20] consists of a collection of essays that raise methodological issues pertaining to the uses of the terms, "Life history" and "Narratives." The authors of the various essays in the book seem to have been struggling with how to differentiate life history and narratives. But, despite the identified differences— the differences identified are not so much about the meanings of the terms but rather how the terms are used in relation to each other depending on the type of research—it is clear that the two terms are mutually inclusive. In blurring the boundaries between life history and narratives, for example, Hatch and Wisniewski argue that individuals' expressions of self and the stories of their lives become sources of data for both narrative and life history

inquiry.[21] Further, Polkinghorne, posits that "life history is always a history of life . . . while narratives may be a style of telling"[22] and therefore the two terms are relational. While I agree that life history and narratives are mutually inclusive, even as separate terms, I choose rather, for the purposes of this study, to fuse the terms together. I will, therefore, refer to life history and narratives as life-history narratives based on the assumption that life history is an account of one's life told through a narrative process.

While insights into women's experiences are important, my primary task is to use life-history narratives as a way of knowing.[23] According to Munro life-history narratives do not merely illuminate women's lives, but rather challenge the "unitary ways of knowing . . . by highlighting the storied forms of knowledge . . . [and] problematizing modern forms of knowledge."[24] Life-history narratives which privilege the lived experiences become an epistemological process by engaging the analytical process of meaning-making or "narrative cognition"[25] through which we know, construct and understand the reality of the world around us. I, therefore, view life-history narratives as a storied way of knowing through which African women communicate trustworthy, valid and useful knowledge about the reality of their lived experiences.

Life-history narrative as a narrativizing process in this study began with encouraging women to define themselves and to recognize their positionality within the society in which they function. African women's self-definitions *vis a vis* how the society defines them, therefore, became an important point of departure to self-discovery as they interrogate their everyday experiences within which their world as women is constructed and lived. Life-history narrative strategies provide the opportunity for women's self-definition, self-awareness and the "shared consciousness" about their everyday life experiences. This self-awareness encodes a political and ideological potential to impact and motivate women to want to change their negated social positions and societal attitudes.

Contextualizing[26] Life-History Narratives

The life-history narrative approach has emerged as an important form of research.[27] It offers "exciting alternatives for connecting the lives and stories of individuals to the understanding of larger human social phenomena."[28] Prompted by the researcher, life-history narratives embody

references to the contexts of various actions and events over the course of an individual's life.[29] Such actions and events are focused on social interactions, personal developments, and the totality of everyday engagements. In the process of storytelling and interpretation, all the events, actions, and linguistic expressions are used by the researcher and the narrator to create a narrative form. Therefore, a narrative is more than just a story. A narrative form can be described as inclusive of not only what is told but also the process of telling, and is a product of analytical interaction between the story, the narrator, and the researcher.

The interview process creates a context in which narratives are created. It involves reflective accounts of, and decision-making on, what to say or not say and what to ask or not ask for the narrator and interviewer respectively. In both cases the interview involves analytical processes to articulate certain situations, nuances, and ambivalences. Because this process of analyzing, self-reflexivity, and making judgements constitutes knowledge production, life-history narratives can be viewed as an important means through which to record and illuminate complexities of our actions that are often ignored.

Women's Life-History Narratives as Sources of Data

Post-modern feminists' assertion that knowledge is socially constructed and that women's storied lives are an authentic form of knowledge has revolutionized conventional research in many ways. First, the use of life-history narratives as a source of data in feminist research is a challenge to the empiricist epistemological paradigm that takes knowledge as objective and that construction of knowledge is only possible through unitary and scientific method. The life-history narrative approach attempts to disrupt the conventional epistemological assumption of universal, rational, and unified forms of knowledge by exploring non-unitary and subjective forms of knowledge construction.[30] In rejecting the notion that knowledge derived from objective methods is the only "Truth" and that the nature of reality is fixed and, therefore, determinate, postmodern feminists argue that there are multiple ways of knowing and that knowledge is subjective rather than objective.[31] Consequently, life-history narratives which portray how every individual makes meaning of his or her everyday life constitutes multiple "truths" and must, therefore, count as knowledge.[32]

Second, by focusing on the lives of women and stories they tell about their experiences, feminist epistemology implies an epistemic gain in using narratives as women's "ways of knowing."[33] According to Bloom, narratives:

> illuminate the course of life over time and the relationship between the individual and society; they demonstrate how women negotiate their "exceptional" gender status both in their daily lives and over the course of a lifetime; and they make possible examination of the links between evolution of subjectivity and its shift and changes and the development of female identity.[34]

Third, by the stories they tell, women make visible their lived experiences, make meaning of the world around them, and work to find their identity. Amidst the conflicts and resolutions of their problems, a certain truth about themselves is relayed and made available for reflection. Feminist methodology, therefore, affirms that what women say about their lives and their daily life experiences constitute "valid and knowable empirical data."[35] The current shift toward the life-history narrative approach to doing research with and for women is to "take seriously the lives of women . . . [and] to acknowledge their conversations as more that just idle talk or mere gossip."[36] African women's storied lives are central to this study, particularly in illuminating women's multiple subjectivities (as wives/absent wives, mothers/absent mothers, educated and professional women), which are often times contradictory and always in flux.

Using life-history narratives to research African women is not a new phenomenon. The telling of stories was inherent in African tradition, particularly because in the early days there was no provision for written words. Stories were used to convey messages and to communicate important legendary information and anecdotes of traditional life to younger generations. However, there was a gendered distinction between the kind of stories that were told. The power relations between men and women played a big role in terms of what passed as a story and what did not. While men not only told stories, but also discussed ideas that were important for the larger community, women's stories were not stories but "gossips." Because women's stories were gossips (and gossiping was a

woman's thing), their stories were rarely believed or taken seriously by the society. I am reminded of a saying in my Kikuyu culture that a woman's story is believed only when it proves to be true, and by that time the damage has already been done. The problem with the women's stories was not in the telling, the problem was that whatever women communicated among themselves was never perceived as important to the rest of the community. Women's voices were, therefore, silent.

What is new with the life-history narrative approach this study embarks on is that women's standpoint through their stories is taken seriously.[37] The central project of this life-history narrative study is to break the barriers of enslavement of ideas and voice by amplifying the women's voices.[38] By privileging their life-history narratives, these women's stories are not only elevated to a higher level of believability, but they also cease to be just stories and become credible accounts of women's experiences.

Buchi Emecheta,[39] an African woman fiction writer, has an incredible talent for telling stories through written text. As I read her novel entitled, *Head above Water*, I vividly remembered precious moments of storytelling with my late grandmother. Storytelling is not only self-revealing, it is transformational, inspirational as well as "therapeutic." And, because women used the stories as avenues to express themselves as women, the storytelling moments were special moments of communicating and bonding with each other as a community of women. The inability to tell one's story, no matter what the circumstances, according to Buchi Emecheta, is a form of enslavement. She asserts that "the greatest type of slavery is . . . the enslavement of ideas."[40] Breaking the barriers of the enslavement of ideas as Emecheta suggests speaks to the belief that life stories are all success stories. Because traditionally African women were not allowed to speak about their inner experiences, whatever they portrayed about themselves in their narratives was always positive and mirrored what society expected of them. When women did things that were perceived to be wrong they were ostracized. Therefore, women's stories tended to be success stories mirroring the "master script"[41] notions of good wives, successful homemakers, and hardworking tillers of land.

The life stories of the women in my study are not all success stories. They are full of uncertainties, ambivalences, and ambiguities. To expect them to have "happily ever after" kind of endings fails to reflect

each woman's reality. This would mask the day-to-day negotiations of uncertainties that constitute the realities of the respondents' lives as reflected in their stories. Therefore, life-history narratives in this study not only focus on the successes but also the failures—those moments of indecision, of losses, of uncertainties—in order to reveal women's vulnerability as well as strength.

In her book entitled, *Under the Sign of Hope: Feminist Methodology and Narrative Interpretation*, Bloom[42] articulates the notion of fragmentation of the self as someone's life, as moments of uncertainty and conflict when one's subjectivity is shattered. Bloom lets us know that fragmentation, though sometimes painful, is not a sign of weakness but an opportunity to grow toward self-identity. I did not, therefore, avoid uncertainties, but sought to identify fragmentations in my respondents' stories in order to present a complete picture of each woman. These moments are storied as important aspects of their lives and show how the women dealt with challenging situations. It is not uncommon that the women are confronted with conflicting situations; they tend to give up their struggles, thus affirming their positions and locations as "powerless and marginalized."[43] However, when women's marginality, ambivalences, and uncertainties are narrated, their sense of their awareness translates into a new consciousness that opens spaces and create conditions necessary for resistance and transformation.

Although telling stories among African women is an important part of the process of rediscovering and gaining their own identity, I am aware that there are cultural barriers within African traditions that prohibit women from speaking about their own inner fears and problems (marital or familial) to outsiders. I am reminded of a saying in my Kikuyu tribe that says "*cia mucii ti como*"—meaning that any information pertaining to the home is not for public consumption. Within the Kikuyu tradition and practice, this adage is strictly adhered to, and women quietly suffer, physically and emotionally, from spousal abuse or any other form of oppression in the patriarchal society. I am also aware that talking about one's problems to other women within the Kikuyu community portrays weakness and lack of allegiance to one's roles as a dutiful and acceptable member of a specified women's group. Historically, the Kikuyu women were assigned to two groups based on the length of period one had been married and the age of the children. Older

39

women, forty years and above were known as the "*Nyakinyua*." Younger women, recently married, and whose children were below the puberty or circumcision age, were the "*Kangei*." The women were supposed to behave according to their age/position's regulations and expectations. The older women were often the guardians of these restrictive traditions and they had the authority to reprimand the younger women.[44] An internalization of such rules and regulations through socialization process would definitely prohibit an open and "truthful" sharing of the account of one's life experiences and ambivalences.

In this instance, how does a feminist researcher deal with the notion of lack of truthfulness or telling a story depicting a "preferred image"? Bloom offers two ways to deal with such a situation. First, she suggests that "women . . . must be encouraged and be given space to *tell* and *retell* their stories, attempting each time to articulate the complexities, confusions, and indeterminances of lived reality."[45] In the process of telling and retelling, the ways in which the stories are told should be as important as what is told. I envision telling and retelling as a way of creating an opportunity for women to tease out layers of underlying gendered meanings that work to shape and blur their "true" identity. Second, Bloom admonishes researchers not to use narratives uncritically but rather approach analysis of narratives with somewhat skeptical or . . . un-idealistic eye."[46] This, I believe implies that the researchers must be more sensitive to the narratives women share by addressing them in the interpretation process.

Sensitivity, however, may not be all that is needed in the process of analyzing women's lives. I hold that there are many other factors (theoretically or methodologically stated or perceived) that determine the styles researchers used to interpret or analyze women's lives. One fitting word that I think might describe what feminist researchers do or should do is "negotiate." While I hold that the process of analyzing and interpreting narratives revolves around negotiating, I recognize also that it would be too simplistic to believe that negotiating solves all problems. Analyzing women's narratives involves a complex process of teasing out and recognizing the power relations inherent in any given research relationships or interactions.

When I was interviewing Tansi, I experienced this culturally internalized tendency to choose not to disclose painful or unpleasant part

of her life and recognized the need for the researcher to negotiate a certain degree of disclosure.[47] Although she opened up later on, especially towards the end of the interview, she was unwilling to respond to some questions which touched on sensitive areas of her life. Negotiating the process of collecting life-history narratives, according to Etter-Lewis, can sometimes be intriguing "because it means making public those miscalculations, unanswered or unasked questions, [and] unexpected reactions of individuals."[48] Through this process, though sometimes painful, however, women rare to transend the harm of cultural silence.

Traditional expectations that discourage women to speak have perpetuated "cultural silence." In their book chapter, "Margins of Exclusion, Margins of Transformation," Martel and Peterat, describe the basis of women's submission and subordination thus:

> Each day of our lives we are informed that women do not count, that we are wrong, that our different descriptions, explanations are ridiculous or unreal. If we try to insist on their validity we can be discounted again, as aggressive or emotional (unfeminine or feminine, but either is wrong).[49]

I argue that the ability to break the silence for women means more than being empowered to speak. It means controlling the form as well as the content of an individual's own communication and gaining the power to develop and share one's own unique voice. By encouraging the women in this study to speak openly about their conflicts and worries, it was easy for them to transcend the cultural boundaries of silence. Identifying and marking such cultural beliefs also illuminated patriarchal undertones that worked to keep the women silent. This reflexive process became an important step toward enabling them to move toward gaining themselves. But as bell hooks[50] says in her book, *Talking Back: Thinking Feminist, Thinking Black*, it is not easy for women to talk back to the society in their homeland countries because of fear of isolation and alienation. Therefore, women would need to establish a collective voice by creating a common bond and through shared collective stories and experiences. Shared experiences among women help bind them together and to create a buffer zone. Richardson affirms that:

By emotionally binding people together who have had the same experiences. . . the collective story overcomes some of the isolation and alienation. . . linking of separate individuals into shared consciousness. Once linked, the possibility for social action on behalf of the collective is present, and, therewith, the possibility of societal transformation.[51]

One of my goals is to document the collective stories of African women studying in the United States and to link these individual women in a shared consciousness. Rosenwald posits that the narrative study of lives "can open a window on the social panorama not accessible from any other vantage point."[52] This study, I believe, will form a basis for constituting women's individual and shared consciousness and become an agent for transformation.

Narratives as a Means to Liberation and Transformation

Liberation or emancipation is the ultimate political goal of feminist research. Liberation is envisioned through creating spaces for silenced women's voices to be heard. When women are able to locate themselves and their gendered identity through storied lives, a process towards self-identity and agency begins. Munro contends that "what becomes essential to rethinking agency and resistance from a gendered perspective is a focus on women's discursive practices."[53] The discursive practices that Munro is talking about are comprised of the varied ways that women tell their stories, the language they use, and the cultural context in which they find themselves.

I am again reminded of my interviews with Tausi. As we were nearing the end of the interview period, she expressed her feeling of freedom and growth by the use of the word "mature." Her use of the word mature portrayed a gained power to move beyond the confines of patriarchy as well as the ability to see the options available to her. The word mature also refered to the ability to get into a position where she could question those beliefs and values that were oppressive to her as a woman. Allen and Baker have persuaded feminist researchers to encourage women to "speak the unspoken."[54] They have implied that there are stories that people do not tell for fear of disclosure and, therefore, the researcher

has been given an obligation to try to elicit them. Gibert and Gubar in the article, "Palimpsest: (Re) reading women's lives," articulate how women combine multiple seen and unseen-layers of meanings to their lives. The authors argue that this situation requires that researchers re-read the "deeper, less accessible levels of meanings."[55] How do we as researchers get the women to speak the unspoken?

Although many feminist researchers contend that emphasis on how the story is told and what is told are important in narratives, many also feel that focusing on what is not told and getting the women to speak out the unspoken can be liberating. Many researchers have pointed to fiction as an alternative form of narrative.[56] Specifically, Bakan argues that "fiction might open doors that cannot be opened by approaches that are too weighed down by duty to literal truth."[57] Zeller,[58] reiterates that fiction—illusions and inner vision—focuses on the unique and the particular, thus providing a way of temporarily removing oneself or detaching oneself from the story revealing ultimately more intimate or private and personal situations than would otherwise be told. Life histories told as fiction often evoke "feelings and emotions [which] occupy a primary discursive space in our daily individual and collective lives."[59] Buchi Emecheta describing the fiction style of her writing states that ". . . although the work was fictitious, it drew heavily upon my personal experiences."[60] Through her autobiographical fiction, Emecheta portrays the struggles of both traditional and modern African women searching for fulfillment while attempting to overcome oppression by patriarchal elements within their own familial contexts and cultures.

Therefore, regardless of the form the narratives take, stories we tell about ourselves and each other as women and with women as "subjects of narrativity . . . women are made to see themselves through a potentially more empowering women's gaze."[61] By making women and women's narratives central in the feminist research process, the hegemonic male gaze, which often leads to the production of a master-narrative that conceals the true identity of women, is challenged. Likewise, focusing on nuances and ambivalences puts women in a position where they can question social structures and thus "neutralizing the forces" that exclude, victimize or keep women in subordinated roles.[62]

In this context, African women's multi-layered marginalization, as portrayed in their stories, was based on societal discourses of femininity,

motherhood, domesticity, education, and professionalism as well as the perception of women's subjectivity as unitary and fixed. Tensions were evidently revealed when African women realized the "multiplicity of their selves" and as their subjectivity became fragmented and continually changed as they negotiated different gender roles, expectations, and positions in their lives. Having the chance to talk about their experiences and to question the structures that marginalized them began a transformative process. Martel and Peterat[63] discussed continuous negotiations of positionality within the "margins" of gender roles and expectations and proposed that this can sometimes translate into agency. Such agency has allowed women to re-conceive the notion of margin and marginalization as possible positions of power and supported the ability to transcend patriarchal boundaries. Thus, women at the margin, at the verge of voicelessness and powerlessness, can reconceive those margins as locations of power with future possibilities. Tenji's contention summarized the respondents' struggles to come to terms with the power of leaving the family. She stated, "It called for boldness. . . . It is your life. All these things [obstacles] can come but they cannot take you away from your life projections."

In this section, I have explored how I have used life-history narrative and why it is an important methodological approach to doing feminist research on, for, and with African women. The use of life-history narratives did not only provide sources of data derived through women's stories, but also offered an opportunity to begin a liberatory process as women articulated their present predicaments and mapped out where they wanted to go. This liberatory process of gaining themselves, I believe, began with a deliberate facilitation of the process of growth in women's collective and individual self-awareness; a growth in consciousness of the past, the present, and the future sources of their conflicting, and consenting identities, and a growth in recognizing what has enriched and inspired those identities as well as what has stifled and oppressed them. Etter-Lewis contends that "we must act with deliberation and commitment in order to ensure that *all* women have a voice and an audience for telling their lives."[64] I wish to conclude this methodological section with a quotation from Richardson, which, I feel, speaks to feminist researchers:

If we wish to understand the deepest and most universal human experiences, if we wish to be faithful to the lived experiences of people . . . if we wish to use our privileges and skills to empower the people we study, then we should value narratives. Marginalizing narrative may serve the political interests . . . but it does not serve . . . society.[65]

The Research Process and Strategies

This feminist life-history narrative study explores and examines the experiences of three African women who defied the homeland traditions that limit the roles of women to domesticity in order to pursue higher education abroad. In this section, I describe the process and strategies of doing this research. Stewart[66] contends that in the interests of "strong objectivity,"[67] researchers must account for the research processes that explain their experiences. An honest account of, and continued reflection on, ourselves as feminist researchers and on our values is necessary if we are to expose the potential biases in our work and engage in reciprocal research relationships.[68]

Engaging in this research project has been a personal journey. It began in the fall of 1998 when I attended my first qualitative research class. I knew deep down in my heart that this was not a class like any other that I had taken. Though I did not know what to expect, I was aware that the time had come for the fulfillment of my desire to learn about qualitative research. As I sat in the class that first evening, I reflected on an incident back home in Kenya at the university where I was teaching. Some of my colleagues were selectively invited to attend a qualitative research workshop. I was disappointed because I was not selected, and the chance to learn about qualitative methodology as a different approach to doing research had been thwarted. How could I have ever guessed that I would get a chance to continue my formal education and attend a class that would teach me what qualitative research was all about? I silently vowed to aspire to be the "best" qualitative researcher. This opportunity appeared like a dream and has slowly but surely been turning into a reality.

Deciding on the Research Topic

My research interest has always focused on the plight of girls' education in Kenya. Informed by the quantitative paradigm, the research projects that I had previously done engaged a detached concept of the relationship between the girls, the problems under study, and myself as a researcher. I was looking at the disadvantaged women and girls as separate entities detached from myself. I thought those "others" always were there to provide the subject, the source, the reasons, and the context for doing research. Feminist theorists have argued that the idea of a detached role for the researcher "bearing to watch silently from behind the camera," is ethically unconscionable.[69]

As I shared my experiences of coming to the United States to pursue higher education with my professor, she suggested that I consider doing a book on the topic. She suggested that I get information from other returning African women graduates to see if they had had similar experiences. At first, this idea did not sound viable. How could such experiences be a topic for a study? Who cares about what women feel or go through in the process of deciding to go back to school anyway? Of what use would such research be? All these questions and thoughts bombarded my mind. I thought that coming to the United States would help me formulate and embark on a research study focusing on a prestigious topic that sounded "serious!"

As the course progressed that semester, we read various scholarly pieces on qualitative research and methodology. It became clear to me that the appropriateness of any research is articulated within the preferred ontological, epistemological and methodological paradigm which determines the primacy of the value-fit to guide the research.[70] I realized that it was not the "sounding serious" of the research topic that authenticated the value of research. Rather, it was how the value-fit guides research in terms of, for example, "what qualifies as valuable knowledge and our perspective on the nature of reality."[71] In other words, how we view a problem or a process as appropriate for research is dependent upon the preferred paradigm which then determines the value-fit as well as the standards for making specific knowledge claims. As I learned more about qualitative research methods and clarified my epistemological stance related to the production of knowledge, my research topic finally did feel "serious." I knew that I wanted to generate knowledge to help better understand

African women's experiences. I decided, therefore, that this would, indeed, be the perfect topic for my study.

Identifying the Respondents

I defined my respondents for my book as married African women who had left their families in Africa to pursue higher education in the United States of America. Drawing from my own experience of coming for further studies in the U.S., I envisioned that other married women must have undergone a similar vigorous process of decision-making. I thought studying married African women would be different from non-married women because the decisions would likely yield more insights into their life experiences. I did not, therefore, consider those who were not married or those who were married but had their families with them in the United States of America.

As my research progressed, I realized that gaining insights limited to the women's experiences in the United States was not enough. It became important to get the bigger picture of how, after attaining higher professional degrees and spending a long period of time away from home, these women were able (or unable) to fit back into their culture and professions. I argued that understanding these dynamics would yield rich interpretations of the issues by linking women's experiences to different time frames and different contexts in their lives. I, therefore, purposively[72] identified three African women as key respondents for this study. Purposive selection enabled me to identify specific respondents who could provide appropriate information and share meaningful data which I needed to understand the problems and educational experiences of African women studied abroad.

I identified one African woman (Tausi) who was a current student pursuing a Masters degree in the United States. The other two (Tamara and Tenji) studied in the United States and subsequently returned to their countries in Africa, where I interviewed them. I used pseudonyms and changed other essential features, like the names of their home countries and the institutions in which they studied, in order to maintain their anonymity.

Data Collection: Interviews

As a recipient of a Women's Studies' summer scholarship grant,[73] I was able to go back to Africa for three months, from May to August 1999, to interview Tamara and Tenji who had already returned to Africa. Upon my return to the United States, I interviewed Tausi, who was pursuing her Master's degree. I conducted informal, in-depth interviews[74] consistent with major tenets of feminist epistemological and methodological theory.[75] I conducted five one-hour informal in-depth interviews with each of the respondents in Africa and the U.S. I sought their permission to tape record all interviews. In regard to my position as a researcher and as the sole instrument of data collection, I took full responsibility of maintaining reciprocity.[76] Reciprocity establishes an interpersonal relationship necessary for collecting narrative data by removing barriers between the researcher and the researched.

Guiding Questions

In studying these women's narratives, it was not only paramount to understand how they experienced and negotiated various obstacles and contingencies in pursuit of higher education, but also how they made meaning of those experiences. A life-history interview asks about an account of a life and uses open ended and exploratory questions. Unlike structured questions, open-ended questions allow the respondents to decide and talk about the issues that are important in their lives. I used the following general questions to guide and set the parameters of the study but subsequent questions were generated from the respondents' stories and responses: Why did the women choose to go for further studies abroad? What motivated them? What obstacles did they encounter? How did they deal with these obstacles? What changes did they experience in their lives? How did they experience their world when they went back to their home countries? What are their educational aspirations and opportunities at home? What implications did their decisions have (and continue to have) for their lives as women, their families and the society in general?

The life history interviews with the women were open-ended and allowed the women to talk about the life experiences that were of importance to them. However, I narrowed the focus on which the in-depth interviews were based by doing a thematic analysis of their educational expe-

riences as they were mediated by the African culture and the concept of "moving away" to go abroad. According to Taylor and Bogdan, "researchers make decisions about what to observe, ask about, and record [which] determine what they are able to describe and how they describe it."[77] In addition, because this study was geared towards documenting the African women's experiences in pursuing higher education abroad, I became sensitive to words, like empowerment, which were so central to women's narratives in portraying how education in the United States had transformed their sense of self. This explains why the women did not give detailed accounts of their specific experiences such as sexism and racism.

Establishing Interview Relationships

I found it difficult to think of my conversations with my respondents as interviews. The relationships that I established with my respondents were more reciprocal and egalitarian.[78] The stories the women told did not occur as monologues but rather, as a product of an emergent relationship between each respondent and myself. Feminist researchers have advocated for the use of relationships, intuitions, emotions, empathy, and experiences as sources of knowledge that represent human experiences.[79] First, I tried to build this relationship by interviewing the women in their own homes. The setting or location of the interview, according to Christman,[80] can automatically change the mood from an intimidating formal interview to a relaxed conversation in the familiar environs of a home. Second, I did not enter into their lives as a stranger to their experiences. We had taken similar trajectories, as professional colleagues, and as married African women who had pursued or were pursuing higher education abroad. Our shared status blurred the researcher/object distinction and instead became the main bond that brought us together into an exclusive relationship. This shared status further allowed and created a form of solidarity that encouraged the women to speak of issues pertaining to their innermost fears and concerns. Through the reflective process, I tried to understand how each of my respondents defined and acted on the meanings they gave to their actions and decisions at various points in their lives. Reflection on the dynamics and values inherent in the research process and context was a means of making sense of the world as it is, with its contradictions, contingencies, tensions, and indeterminants.[81] In-

terviews conducted this way facilitated a grounded theory approach in which emergent themes guided subsequent interviews as well as the development of analysis and new theory.[82]

I kept field notes that described the sites and any other field occurrences and observations; methodological journals that described my interview strategies and my decision-making process; theoretical notes from which grounded theories emerged and evolved and personal notes that described my thoughts and experiences in the research process. This information supplemented the member checking process of data analysis to ensure effective triangulation. Upon my return to the United States, I continued extended interviews with my respondents through e-mail.

Making Sense of the Narrative Data

The analytic task inherent in feminist research involves the unfolding of the mystery of creating a "scholarly" piece of work out of jumbled interview transcriptions, field-notes, and observations. Forte rightly states that:

> Writing an ethnographic monograph . . . involves breaking up vivid kaleidoscopic reality of human action, thoughts and emotions which lives in the anthropologist's notebook and memory and creating out of pieces a coherent representation of society.[83]

Methodologically, the analytic task "requires decisions about form, ordering, style of presentation and how fragments of lives that have been given in interviews will be housed."[84] The researcher puts the stories onto another level by generating new perspectives of viewing, for example, what is said and how it is said.

The analytic task allowed me to examine the stories deeply in order to see the cultural processes that engendered experiences and identities. Cultural processes also revealed how stories, as discursive systems of meaning-making, determined how women engaged in specific and personalized contexts. The product of this analytical process, therefore, is this book text[85] which constitutes my closest approximation of reality[86] and which allowed me to see women's lives clearly and to reveal issues of feminist concerns. The analytical process also generated relevant feminist

theories that can form the basis for social change. Behar[87] proposes that in the very process of analyzing our respondents' narrative we risk producing a hybrid story or a "false document." I aspired for believability by being up-front about my approach pertinent to analytical interpretations. I articulated, where necessary, my position as a researcher and my basis for making any knowledge claims.

At the onset of this process, the taped interviews were transcribed and the data coded into thematic categories derived from common and recurrent themes from the stories. Each respondent's personal experience narratives were analyzed using various feminist interpretive theories and methods. In my interpretive analysis of the women's narratives, I also used Pamphilon's[88] concept of the "Zoom Model" to analyze life histories. Based on a metaphor drawn from photography, the zoom model allowed for the examination of narratives from the following different perspectives and levels. The macro-zoom level focused on the socio-cultural dimensions of the narratives and explored collective social meanings as they relate to an individual's experiences. The meso-zoom level focused on the individual's process of storytelling. This helped me to capture the subtleties of storytelling by focusing on the emotions and voices of the women. The micro-zoom focused on the oral dimension of the life history. The oral dimension revealed the depth of the meanings of the words used, thus reflecting the feminist commitment to maximizing the emotional and affective complexities of life histories. Finally, the interactional-zoom level which recognized narratives as a product of the relationship between the narrator and the researcher and that as researchers, we must also step into the "focus/zoom" and declare our interpretive role.

The interactive zoom allowed me, as a researcher and as an African woman graduate student, to use my "embodied subjectivity"[89]—my own knowledge and experiences—to help interpret and understand the phenomenon. This again resonates with Harding's notion of putting the researcher and the researched in the same critical plane.[90] By zooming in and out of the "public discourse"[91] on women's education, for example, I was able to examine "[w]hat has been left unexamined . . . the social organization that generates these actual properties of experience."[92] The public discourse, according to Kiluva-Ndunda[93] referred to the social, cultural and political structures, which are often taken for granted and rarely

scrutinized. Without a space for such scrutiny in feminist research, any form of activism is hindered. "Because narrative accounts are . . . a means of providing panoramic description of realities,"[94] zooming in on multiple perspectives of these realities, revealed differing, complementary and even contradictory data. Zooming in on these multiple realities also held in tension women's individual and collective meanings of a particular phenomenon, allowing for the creation and emergence of new possibilities for knowledge.

Further, because this study examines the interaction of African women's different individual subjectivities within the historical, social, cultural, and political locations, the zoom model can assist in charting and analyzing significant moments of rupture when women's subjectivity become "fragmented."[95] Charting significant events allows me to consciously see and relay how women move within and negotiate such moments individually and collectively. The goal of this analysis and, indeed, that of this study is "perspicacity,"[96] the capacity to build sound, coherent, and applicable grounded feminist theoretical and conceptual explanations as well as insightful interpretations of the women' experiences. Perspicacity is essential for this study as a basis for delineating findings and subsequent recommendations. Finally, the process of cross-case analysis facilitated identification of issues for further research.

By using feminist life-history narrative methodology to study African women who have left their families to further their education in the United States, I recognized the importance of the stories they told and the meaning they gave to their experiences. I also recognized and upheld the importance of such stories and meaning not only as sources of strength and purpose for these women, but also as a basis for informing the current practice and discourse on women's education in Africa. Toward this end, this study aimed at documenting, amplifying and giving voice to these experiences, which have remained in social and political oblivion for so long.

Feminist epistemology holds that listening to and documenting such narratives not only gives voice and validity to women's experiences as acceptable ways of creating knowledge for and about women in Africa, but also reveals women's subjectivities as sites of resistance to gender stereotyping and other ideologies. Theories grounded on, and generated from, such knowledge will not only be used to challenge and subvert the

existing private and public discourses on women's education in Africa, but will also create spaces for informing and imagining new ways of reconstructing social, cultural, political and economic structures in order to recognize and uphold women's rightful position in the society. In the feminist spirit of activism, this study illuminates women's plight and the need to revisit educational and development policies that perpetuate gender inequalities and stereotypes that curtail women's access to educational opportunities. And, by arguing for a relevant and comprehensive feminist theoretical framework for informing studies on African women, I recognize the potential force encapsulated in feminist thought to unleash new ways of viewing and using feminist research as a tool for creating knowledge and for strategizing liberation for African women.

Ultimately, I also recognize that improved educational opportunities alone without allowing for women's self representation will neither translate into improved status nor better development policies for African women. Self-representation can only be made possible by listening to women's stories about how they view and make meaning of the world as women and by taking such stories seriously in dealing with matters that concern women.[97]

Self-Reflexivity

I situated myself within the analytical interaction of African women's narratives by engaging a reflective approach as a way to deal with life histories, especially when one is researching "within-group."[98] Drawing on Harding's[99] articulation of the goal of feminist methodology, Bloom observes that "the researcher learns to openly locate her history, values and assumptions in the text so that she, like those researched, are open to critical scrutiny by her readers."[100] Self-reflexivity "locates the deeply personal and emotional experiences of the researcher as a subject in a context that relates to larger social issues."[101] I concur with Ellingson's contention that through self-reflexivity:

I move beyond the "Othering" of my research subjects by placing myself as part of the group under study and viewing my own experiences as "data." I seek not only to understand them, but also me and, most important, us.[102]

Through the process of self-reflexivity, I was able to use my "embodied subjectivity"[103] to identify, and analyze African women's life-history narratives in ways that represent our lived reality. As Tierney rightly says, reflexivity confronts dominant forms of representation and power in an attempt to reclaim the representational spaces.[104] As Bloom also observes, "by disclosing and analyzing her identity and values, [through reflexivity] the researcher asserts both that what she knows cannot be separated from who she is and that her warrants for making knowledge claims are subjectively situated and historically contextual."[105] To be reflective called for disclosure rather than erasure of moments of vulnerability and messiness of our experiences as researchers. Self-reflexivity allowed me to engage my respondents' life-history narratives as they reflected on my own, thereby, evoking an empathetic understanding of our lives. But of much more importance was when, through this reflective collaborative engagement of our collective life histories, my respondents and I began to see patterns, similarities, and peculiarities in our lives as African women. Reflecting on these moments became the first steps in understanding our lives in a reality unmediated by biased social construction of who we are. I, therefore, argue that any method capable of invoking empathy is desirable for illuminating women's lives. As Behar observes, ethnography that "does not break [our] heart[s] just isn't worth doing anymore"[106] because how else would we as feminists convey the obscured reality of women's lived lives?

Notes

1 Bloom, 1998, p. 139.
2 Bloom, 1998, p. 138.
3 Schawndt, 1989, p. 399.
4 McDonald, 1989, as cited in Aina, 1998, p. 66.
5 McDonald, 1989, as cited in Aina, 1998, p. 66.
6 Chris Weedon, 1987, as cited in Mama, 1995, p. 8.
7 Frese and Coggshell, 1991.
8 Bloom, 1998; Collins, 1990; Harding 1991; Munro, 1998; Smith, 1987.
9 Collins, 1990; Smith, 1987; Weiler, 1988.
10 Weiler, 1988.

[11]Harding, 1987.

[12]For example DeVault, 1999; Harding 1987; Reinharz, 1992.

[13]DeVault, 1999.

[14]Mama, 1995; 2003.

[15]Collins, 1990; 1998.

[16]Bloom, 1998, Munro, 1998.

[17]DeVault, 1999.

[18]Lather, 1991.

[19]Polkinghorne, 1995, p. 5.

[20]Hatch and Wisniewski, 1995.

[21]Hatch and Wisniewski, 1995.

[22]Polkinghorne, as cited in Hatch and Wisniewsku, 1995, p. 115.

[23]Goldberger et al, 1996; Munro, 1998; Polkinghorne, 1995.

[24]Munro, 1998, p. 5.

[25]Polkinghorne, 1995, p. 9.

[26]Fore-grounding and/or locating narratives as a mode of inquiry.

[27]Hatch, 1995; Constas, 1997; Bloom, 1998.

[28]Hatch and Wisniewski, 1995, p. 113.

[29]Personal Narratives Group, 1989.

[30]Personal Narratives Group, 1989)

[31]Goldberger, 1996.

[32]Sachs, 1996; Nicholson, 1990.

[33]Goldsberger et al, 1996, p. 262.

[34]Bloom, 1998, p. 148.

[35]Bloom, 1998, p. 150.

[36]Munro, 1998, p. 5.

[37]Collins, 1990; Smith, 1987.

[38]Emecheta, 1989.

[39]Buchi Emecheta, 1986.

[40]1986, p. 204.

[41]Bloom, 1998, p. 66.

[42]Bloom, 1998.

[43]Martel and Peterat 1994, p. 154.

[44]Kenyatta, 1962.

[45]Bloom, 1998, p. 67, emphasis mine.

[46]Bloom, 1998, p. 147.

[47]Tausi (pseudonym), one of the women I interviewed.

[48]Etter-Lewis, 1996, p. 115.

[49]Martel and Peterat, 1994, p. 158.

[50]bell hooks, 1989.

[51]Richardson, 1997, p. 33.

[52]Rosenwald, 1996, p. 269.

[53]Munro, 1998, p. 2.

[54]Allen and Baker, 1992, p. 11.

[55]Gilbert and Gubar, 1979, as cited in Jacobs and Munro, 1995, p. 327.

[56]Emetecha, 1986; Bakan, 1991; Hatch and Wisniewski, 1995; Stivers, 1995; Zeller, 1995.

[57]Bakan, 1991, p. 7.

[58]Zeller, 1995.

[59]Richardson, 1997, p. 65.

[60]Buchi Emecheta, p. 112.

[61]Bloom, 1998, p. 69.

[62]Harding as cited in Allen and Baker, 1992, p. 9.

[63]Martel and Peterat, 1994.

[64]Etter-Lewis, 1991, p. 6, emphasis mine.

[65]Richardson, 1997, p. 35.

[66]Steward, 1998.

[67]Harding, 1987.

[68]Reinharz, 1992.

[69]Behar, 1996, p. 1.

[70]Schwandt, 1989.

[71]Glesne and Peshkin, 1992, p. 5.

[72]Patton, 1990.

[74]Women's Studies Program at Iowa State University gives grants of between $500 and $1,000 to faculty and students to do research during summer session. I was honored to received this grant in the summer of 1998.

[74]DeVault, 1990; Lather, 1988; Oakley, 1981.

[75]Harding, 1987.

[76]Harding, 1987; Bloom, 1998.

[77]Taylor and Bogdan, 1998, p. 36.

[78]Oakley, 1981.

[79]Jaggar, 1989.

[80]Christman, 1988.

[81]Fonow and Cook, 1991, cited in Bloom, 1998.

[82]Glaser and Strauss 1967.

[83]Forte, 1970, as cited in Jacobson, 1991, p. 4.

[84]Riessman, 1993, p. 13.

[85]The term, "text" in ethnographic discourses has many meanings. I use this term to specifically refer to the written text in form of this disseration.

[86]Harding, 1991.

[87]Behar, 1996.

[88]Pamphilon, 1999.

[89]Wolf, 1996, p. 13.

[90]Harding, 1987.

[91]Kiluva-Ndunda, 2001.

[92]Smith, 1987, p. 97

[93]Kiluva-Ndunda, 2001.

[94]Macauley, 1996, p. 3.

[95]Bloom, 1998.

[96]Stewart, 1998

[97]Terborg-Penn, 1995.

[98]Mama, 1995.

[99]Harding, 1987.

[100]Bloom, 1998, p. 148.

[101]Denzin and Lincoln, 2000, p. 232.

[102]Ellingson, 1998, p. 510.

[103]Wolf, 1996.

[104]Tierney, 1998.

[105]Bloom, 1998, p. 148.

[106]Behar, 1996, p. 177.

Chapter Three

"IT'S LIKE WATCHING A MOVIE": TAUSI'S NARRATIVE

In every life there are experiences, painful and at first disorienting, which by their very intensity throw a sudden floodlight on the ways we have been living, the forces that control our lives, the hypocrisies that have allowed us to collaborate with those forces, the harsh but liberating facts we have been enjoined from recognizing.[1]

In this chapter, I present an interpretive narrative account of Tausi's inner self, the pains, the struggles and ambivalence that constitute the life of an otherwise successful and achieving African graduate student. In my introduction, I discussed the tension between domesticity and education and how this tension creates conflicting demands on the lives of African women. Using Tausi's narratives, I address the tension between domesticity and education and explore ways in which her experiences reflect and respond to this tension. Although I interviewed Tausi in the United States, her narratives, as depicted by the metaphor of a movie, reflected more on her experiences during the time of the preparation to come to the United States and upon her arrival. Her narratives also focused on the reasons that led her to seek an education abroad. As she states in her narratives, coming to the United States provided a life-chang-

ing moment when she was able to reflect on her life as if she were "watching a movie," undisturbed. I identify the time of growing up, her marriage and career, and going back to school as important turning points in her life. I discuss how these turning-point experiences are, as Luttrell expresses it, "entangled and at odds, interwoven and warped" within a social context to inform, shape, reshape and challenge her identity and professional destiny.[2] Throughout the discussion, I highlight how Tausi challenges the social construction of domesticity through the processes of self-identification, self-realization, and self-reflexivity, particularly, as she deals with resistance from her husband due to her decision to eventually leave for further studies abroad.

During one of my interviews with Tausi, I asked her to share her experiences since she came to the United States. After a short pause, she said:

Having been here [U.S.] has allowed me to reflect on a lot of things about myself. I have moved out of the situation. Now I am looking at it from the outside. It is like I am watching a movie and saying Wow . . . look at that. And the other thing is the reflection, the time I have been here, I have had time to listen to myself and my mind and every thing. So, it is like I went to a quiet place and, you, know, that has really helped me.

Describing her life using the metaphor of a "movie" denotes the reflective mode of storytelling that Tausi uses throughout the interview process. Metaphors, according to Roger and Freiberg,[3] are very powerful symbols that convey a very deep meaning of a particular phenomenon. Through this reflective process she is able to judge herself and her actions at different levels and points in her life. By viewing her life as a movie, Tausi also ceases to be an actor in the cast of her life; instead, she becomes a spectator. Normally, a spectator is not a part of the cast and, therefore, he/she can judge, detect mistakes, criticize, correct, reflect, and interpret different scenes. Tausi is having a time of self-reflection and trying to make sense of her life by temporarily removing herself from it.

Through the process of self-reflexivity, Tausi is not only watching her life as a movie; she is also "listening" to herself. The process of listen-

ing to oneself requires peace and tranquility in order to come to terms with the realities of one's life. Very often we are preoccupied with individual or societal pressures that inevitably form a crucial part of our daily lives. As a mother, wife, and an executive officer in the Agricultural Institute in her country, Tausi implied that she led a busy and stressful life. She was an active actor. As it is evident with women professionals in Africa and elsewhere,[4] in order to prove themselves and develop their careers, they work with "passion and fervor in a nearly exclusive domain of men."[5] For many women, this struggle to perform is overwhelmingly arduous and leaves little room for "reflection and self-scrutiny."[6] For Tausi, coming to the United States removed her from this hectic life and provided a time for reflection. In the midst of all that is happening in Tausi's life, she has indeed begun the process of discovering her self and her identity. Using the metaphor of a movie, Tausi identifies important landmarks in her life that make up the story line. In the following pages, I highlight these landmarks as significant life transforming moments for Tausi.

Conflicting Socialization in Tausi's Early Years

In the initial stages of the interviews, I wanted to get as much information as possible about Tausi. This was important to me in order to lay a foundation that would henceforth direct and guide the subsequent interviews. In response to my question about how she grew up, Tausi had this to say:

> I was raised by somebody who believed in education. My father did not go to school much. My mother was a primary school teacher but she quit a long time ago. My father was a senior livestock officer. He retired in 1977 to go to full-time farming and other business. He did STD 6 and then he went to train as a livestock officer. So I had a father who believed in education.

Tausi's childhood seems to have had a head start. She had a father who "believed in education" and a mother who "was a primary school teacher." It followed, therefore, that education was not only central to how

Tausi grew up, but also to what she perceived as the basis of her values in life. For an African family to have two employable parents with an education, during the colonial and postcolonial period, was really an advantage. In most African countries, it was not until the period immediately after independence that witnessed a heightened emphasis on increasing opportunities for Africans to access formal education.[7] Education was seen as a means to a good and prosperous life reflecting the kind of life led by the colonialists.

Because education was necessary for securing white-collar jobs previously held by the colonial elite,[8] it followed, therefore, that the aspirations for the African parents at that time were for their children to have an education in order to improve their chances of landing good jobs; this is still true today in most African countries. Tausi's parents were indeed advantaged because they had jobs and earned salaries that placed them in a better economic and social status. Tausi affirmed this when she rated her family in the upper bracket of economic well being "because my father worked and he had cattle. We also ploughed." Ownership of cattle was and is, even today, a mark of wealth and status in many African societies. Tausi's family was, therefore, atypical of an African rural family because of the monetary security that accrued from paid jobs attained through education and from cattle.

Because Tausi's family upheld high educational values, the consequent "push" for her to get an education contradicted the African traditional belief about socializing and educating girls. Further, because education and its benefits had been an integral part of Tausi's up-bringing, they had influenced the way Tausi not only thought about what it meant to be successful, but also the way she made her decisions about education as a means to success. Therefore, I saw that her values about success in life were not based on being primarily a mother and a wife, but also on being a professional. This duality created a tension that she has dealt with throughout her life.

In her book, *Women and Power*, Rosalind Miles refers to and describes the type of family Tausi had as an "empowering family." She states that "high achieving women come from family backgrounds where, in the course of their growing up, they learn that they can be strong, competent and successful."[9] Tausi's family was indeed empowering in the sense that all was there for her to see and experience. However, the case was different with Tausi's younger sister. Even though she too was with-

in the empowering family, Tausi described her as "a delinquent. She quit school when she was in Form One [ninth grade], she started having babies." This statement conjured up nuances in my mind about many issues. For example, was there something more than just an empowering family in determining the academic progress of an individual? What motivated Tausi but not her sister to pursue an education? Why did Tausi's sister start to have babies at an early stage?

Miles states that a girl's learning to be powerful is not a question of parents giving their daughter everything. Rather, it is a "case of a series of interlocking experiences in which the parents are of central but not exclusive importance."[10] Therefore, Tausi's emphasis on education may have been motivated by factors other than, or in addition to, the empowering family. Likewise, Tausi's sister may have been compelled by other factors to drop out of school and start having babies. In Africa, it is not uncommon to find young girls abandoning school to be married and to have children. Culturally prescribed roles for girls, especially in the domestic sphere are glorified and therefore appeal to girls to want to take them up. When girls do not have other choices to make, aspiring to fulfill these domestic roles becomes their only option. Although Tausi was socialized into these gender norms she, unlike her sister, resisted them because they conflicted with her strong beliefs about education.

Tausi's story about her family revealed that she was socialized in multiple ways. However, gender socialization conflicted with educational socialization. On the one hand, we saw Tausi being socialized into gender norms: First and foremost, she was socialized as a girl, then a first born girl, and finally a civilized young woman. On the other hand, she was socialized into valuing education, which was contrary to the gender norms. During the earlier stage of her life, there was no difference in the chores Tausi and her brother did around the home. But as she got older, she explained things changed. "I was supposed to behave like a young woman—sit like a lady or be told that ladies don't shout [laugh] and stuff like that." The interplay between the multiple selves in Tausi's life sometimes became a driving force towards success and at other times, a source of personal conflict. The emotional and physical contradictions of the interplay of the domestic and educational expectations became forces that Tausi dealt with throughout her narratives. Because of the pain and

ambivalence of such contradictions, conformity to domesticity often becomes the comfortable choice for most girls in Africa because of the fear of being different and the sense of "security" that marriage seems to promise women. It follows, therefore, that those girls, like Tausi, who choose to deviate from or reject gender norms face a plethora of challenges that require extra-ordinary drive and courage to overcome. But, unlike many other African girls, Tausi had other added advantages that helped her to move on.

TAUSI'S LIFE IN SCHOOL: "BEING THE TEACHERS' PET"

Tausi had several added advantages besides having come from an empowering family and having an incredible personal drive. When I asked her about her added advantages that may have had an impact on her value for education, she said it was "being the teachers' pet" in school, which she loved.

> **Mumbi:** I would like you to reflect on your school days—when you were growing up—may be in primary school. Is there anything you can you can remember that had an impact in your life?
>
> **Tausi:** I was my teachers' favorite—a kind of pet. You know—I came from the so-called rich family. My observation is . . . girls or students from such families . . . most of the time teachers liked you . . . because of [nicely] dressing and the way you behaved; you were not a [traditional] rural girl. The other thing is that I was boasting that every time the teacher had our books I would know that mine would be left on the table to be read as an example to the rest of the class.

Teachers' approval (or lack of it) is a serious issue. Most students' perceptions of who they are and what they will become is largely shaped by their interaction with their teachers, particularly, in their early stages of their identity formation. In her book, *School Smart and Mother-wise: Working Class Women's Identity and Schooling*, Luttrell[11] gives a

detailed account of the effect of schooling on Black women in Northern Carolina and White women in Philadelphia—a rural and an urban community respectively. Because of its relevance in its application to African women's context, I draw on Luttrell's concept of "teacher's pet" to help understand Tausi's schooling experiences. I interrogate how becoming a teacher's pet, particularly among the Black women, is played into the intersection of race, class, and gender to either undermine or enhance Black women's school experience, senses of legitimacy, and self-worth.

According to Luttrell, those girls who were not teachers' pets had a constant "reminder that they were not worthy of competing for social mobility"[12] and, therefore, had no reason to continue with school. On the contrary, those who were teachers' pets almost always excelled. Tausi contended that her teachers' favor was as a result of her "polished" mannerisms—she did not dress or behave like a "rural" (read: traditional) girl." Her mother's constant prodding to behave like a "lady" seemed to pay dividends here. The notion of being lady-like or behaving like a lady is derived from the mannerisms portrayed by the colonial masters' wives.[13] In the post colonial educational setting, the display of European mannerisms confirmed the desired transformation away from the repulsive traditional African way of life into a civilized world through Western education and religion. During colonial times, everything associated with the Whites was perceived as superior. Therefore the term "lady" was an icon of "polished" behavior that ensured approval into the world of modernity and civilization. Revered were the European ways of life although the distinctions had more to do with the cultural differences rather than what was moral or appropriate behavior. All these were manifestations of the colonial hegemonic tendencies to ensure dominance and subsequent relegation of African culture to the "primitive" status. Education, through which African girls and women were supposed to be modernized to become "ladylike" and shun the primitive ways, was, therefore, problematic because it marked the beginning of a form of dislocation from the traditions and the society.

Thus, while White girls in the United States may actually enjoy being teachers' pet, Luttrell's study indicates that the notion of teachers' pet is a mixed bag of positive and negative consequences for Black women. This can also apply to African girls' experiences with education. For example, in Tausi's case, formal education leads to fragmentation of

her identity in many ways. She is actually negotiating her identity both as an African girl raised in a traditional context, and a "polished" and schooled girl who must denounce being traditional and take up lady-like mannerisms in order to fit in the world of modernity. Being teachers' pet reinforces this fragmentation by endorsing the "polished girl" trait and, thereby, alienating Tausi from the rest of the girls and the community. Therefore, formal education was not only a process that changed one from being "primitive" and rural to being ladylike and civilized,[14] it was also a tool for engendering cultural and social isolation. Indeed, schooling and being teachers' pet reinforced each other in the process of isolation that progresses throughout Tausi's life-history narratives.

TEACHERS AS TAUSI'S ROLE MODELS

Tausi's experiences as a teachers' pet greatly influenced her perception of her teachers as role models. She had the opportunity to interact and identify with successful women teachers who became her role models. Role models are not just individuals who have qualities to be emulated; they are also mentors who help set standards or goals and assist the mentee in working towards achieving them. Not many young African girls are lucky to have women role models early enough to make a difference in their lives. In most cases there aren't any women role models. Historically formal education in Africa was associated with men because the missionaries and the colonialists targeted men rather than women.[15] Women who opted for education were accused of denouncing their traditional roles as mothers and wives and aspiring to be men. And because patriarchy as a system is dependent on, and sustained by, continued subordination of women, women's education in Africa is perceived as a threat to patriarchy, and, therefore, suspect. Patriarchy as a dominant system also uses its values as standards with which all other systems are evaluated. It is no wonder that those women who pursue education do not always fit into the patriarchal definition of role models because of the stigma attached to their identity as societal deviants. This explains why many African women do not aspire to seek education and hence lack of role models for young African girls.

Tausi recalls vividly the impressions the role models made in her life when she said:

The role models that I had—most of them were teachers—women, the ladies. I looked at this particular woman who was educated and came from the university, was well dressed and could teach and was beautiful. Those are the people that I kept saying that one day, I want to be like them.

In observing the transformative power of role models, Sidel[16] contends that the impact of role models is fundamental in the way many women view themselves and experience their roles, their rights and their responsibilities. We perceive role models as representations of the values and lifestyles we would like to embrace. Therefore, the impact of the role models on our lives depends on how our internalized values resonate with, and are reflected in the lives of the role models and the belief that such kind of life is possible. While Tausi attributes her success to the role models she had, her understanding of the role models is important because it reflects her internalized views about who a role model should be. Notably, Tausi uses the words "the ladies," "well-dressed," "beautiful," and "educated" as attributes that describe a role model. Reflecting on the role of education during the colonial time, education for women reflected those values and attributes that mirrored the colonial, white, missionary woman. These values and attributes were inculcated in the process of schooling. It is no wonder that Tausi describes her role models in the terms that reflected the attributes of the colonial concept of a good role model because being a good role model meant being ladylike, beautiful, and educated. Further, the educated woman had to be a teacher because that was all what women could possibly be.

Tausi's internalized perception of what a role model should be is problematic. Although Tausi challenges patriarchy in her narratives, she sometimes finds herself entangled in the same values she is trying to challenge. Her conception of the role models is one of them. It is not only sexist, but also masks the contributions of remarkable African women who may not necessarily be educated. In addition, although her mother was a primary school teacher before she quit to stay at home, Tausi never referred to her as a role model. Rather, Tausi acknowledged her father's

influence on her life more that she did her mother's. She tended to focus her concept of "role models" on those associated with education rather than domesticity, which again brings out Tausi's nuanced and conflicted ideas about education and domesticity. By not acknowledging her mother's position as a teacher, a mother, and a role model, Tausi seems to be affirming the same things she is challenging—the dichotomy between domesticity and education as well as the internalized patriarchal dynamic of power relations between father and daughter.

In the narrative about the time she was growing up, Tausi mentioned that she was "brought up by somebody who believed in education." She said that her father "pushed" her to aspire to do well in school. In her adulthood Tausi still seems to be responding to her father's influence. The internalized values of education, reinforced by the rhetorical advice from her father, became the driving force behind her desire to pursue higher education. Tausi recalled with nostalgia her father's final words before he died:

> I knew all along that you are a believer in education . . . I am so happy that you have decided to go back to school. I knew this is what you've always wanted. Never, ever allow a man to say, "Don't go to school."

Tausi's father's words are very strong. By use of the phrase "I knew all along," he seems to be re-affirming what he had observed of his daughter. At the same time, he is warning her about the patriarchal mode of dominance when he says, "never, ever allow a man." It is, therefore, evident that Tausi's father is aware of his daughter's vulnerability in a patriarchal society of which he has been a part. Evident here, are the conflicting ideologies based on the perceived values of education and domesticity, and the desire of a dying father to protect his daughter from becoming a victim. That Tausi has indeed internalized the educational values imparted by her father during childhood is evident in the way these values mediate the process of decision-making as it is portrayed in the above narratives. However, it is evident that in most instances these conflicting ideologies and values become, in their own right, threads that weave the fabric of Tausi's nuanced life. The metaphor of fabric is important in showing that though most of these ideologies are conflicting, they are never easily discarded or erased from Tausi's

life. Rather, they are interwoven through constant pondering of issues as Tausi authors her life through making difficult decisions and trying to make meaning of different situations in her life.

The need for role models cannot be over-emphasized in encouraging women to access education. As seen in Tausi's case teachers played a big role in Tausi's decision to continue her education. However, I posit that African women need to articulate a much wider definition of role models to include not only teachers but also other women who have made a mark in their lives and lives of others. And because redefining role models will work to subvert the patriarchal standards and terms, those perceived as role models will not only be women who have succeeded in the male-defined women's positions, but also those who have shown courage in confronting and challenging the unjust patriarchal systems within the realm of education and domesticity. Therefore, by recognizing these women as role models we will be acknowledging their courage in mapping out women's destiny through diverse struggles including that of education. As a reflection of the colonial and African traditions, the present post-colonial Africa still holds true many of the values associated with the dichotomy between education and domesticity. Many women and feminists have continued to challenge the oppressive legacy of domesticity because domesticity as defined by patriarchy discriminates against women who choose to be different. Role models, such as represented by the women in the study, point to the need for women's empowerment through education in order to change the destiny of other African women.

"WITHOUT EDUCATION YOU ARE NOTHING"

After high school, Tausi went to the university and obtained a bachelor's degree in Agriculture. She then worked for about four years as an administrator in an agricultural institute in Africa. However, as a woman working in a male-dominated field, she needed higher qualifications in order to compete for promotions. Tausi was, thus, determined to further her education.

Mumbi: Can you please elaborate and tell me why education is so important to you.

Tausi: Empowerment . . . because without education you are nothing. Not that marriage is bad . . . but education makes sure that you are secure. You make your own decisions without saying "my husband" all the time and especially with the things that concern us women.

Mumbi: Can you please explain to me what you mean by the word "empowerment." How do you think education is empowering to African women?

Tausi: You see, when you get married and start having babies . . . it is like your dream is forgotten. The perception of the women who are not educated is that without the men they are powerless. Education enlightens you to a lot of things that are going on. Sometimes it is the culture or the traditions . . . sometimes we are not just aware of the options that are available to us but education helps you to have an insight of what is going on and you have all these options available to you.

Mumbi: Tell me more about the options you are talking about.

Tausi: You see, in African society, men have more options. It is just the set up, the laws, the policies and the traditions. These have made it possible for them to have more options. For example, look at the land ownership. Even if somebody has not gone to school the land belongs to the man as the head of the family. It is men who benefit. So men, even if they are not educated, they have more options than women do.

The generic word that Tausi uses to describe the reason for seeking higher education is "empowerment." According to Shreve, empowering women means "enabling them to achieve their goals, allowing them to be competent and effective individuals."[17] Empowerment through "consciousness raising" as Shreve puts it is to make us "aware of the societal pressures that oppress women."[18] According to Martel and Peterat, "naming and concurrent realization of marginality foster a deeper understanding of social life [and] it is the seed for transformation."[19] The possibility of empowerment, therefore, conjures up the desire for freedom that is often times covertly cherished by many women in Africa who are aware of their lack of empowerment. However, as the core to freedom, and embodied in education, empow-

erment is perceived by many African women as inaccessible because of lack of means to access it. According to Tausi "without education you are nothing." She sees education as the means to empowerment by becoming economically secure and independent and paving the way for professional development. Tausi relates to all these when she says that, "I am really [a] different person from how I was." Tausi's discussion of being different and being empowered implies having occupied a position of powerlessness in the first place. Interrogating the ideology of power as it relates to the choices women have reveals that a major cause of women's subordinate positions in society is lack of options from which to make choices, and not necessarily in the choices they make.

Education, therefore, implies empowerment which can be developed and achieved through intellectual and political struggles against gender inequality.[20] Empowerment as a concept has emerged as an important issue among critical theorists and feminist thinkers. Underlying such thinking is the recognition that women are disempowered and education is seen as a means to empowerment. Because men have more options, even when they do not have education, women, therefore, need education as a means to empowerment. Only when women become aware and take advantage of the options they have will they truly be empowered in order to break the cycle of domesticity through which women learn to internalize conflicted ideas about what it is to live as a woman.[21]

But for African women, the relationship between education and empowerment is paradoxical. While it is true that education as a means to empowerment helps women to explicitly see their options, it is also true that not all women have access to education and not all women have options. While having an education and an option is a privilege, like that of Tausi and the other women in the study, to take the option is to accept alienation from the society. Being empowered, therefore, is more than being educated or having an option. It is taking a deliberate conscious decision to risk alienation in order to be empowered and to empower other women. Although, it is important for women in Africa to be empowered to not accept domesticity as a "given," equally important is the empowerment of the society to want to change and to make options available for women. But what happened when Tausi decided to further her education abroad and to tell her husband about it?

70

In the introductory chapter of this book, I discussed the tension between domesticity and education that makes women's education problematic. In her study on African women pursuing career development in Britain, Bhalalusesa[22] contended that women's decisions to empower themselves through higher education abroad was almost always resisted and often became a source of family conflict. The process of decision making in our everyday life is complex. It involves making a value judgment over specific issues. The process of decision making, however, becomes more complex when and if the value standards that form the basis of our value judgements are conflicted and nuanced. Our identities as males and females, constructed through the socialization processes become the basis upon which conflicted value judgement are enacted. As Miles notes, "the source of conflict [in decision making] lies inside us . . . in our own earliest experiences and understanding of what it means to be male or female."[23] The decisions that Tausi made to seek further education abroad reflected all these tensions of gender differentiated values.

In the following section I analyze circumstances surrounding Tausi's decision to go for further studies abroad. According to Bhalalusesa,[24] the challenges women face in trying to advance their careers are mainly social-cultural and psychological. Decision making for Tausi was not easy. There were conflicting values, ideas and beliefs about her domestic obligations and her educational aspirations throughout her decision-making process. I discuss these conflicts in the following thematic categories: Bridging the gap, empowerment and family conflict, and taking a big step.

Tausi's husband, Kim, completed high school after which he joined a mining company in Africa. He served as an assistant manager after working for the company for over twenty years. However, because Kim did not have a university education, he was not due for any more promotions. I asked Tausi to talk about her husband's reaction when she decided to pursue further education abroad.

Mumbi: How did your husband react when you decided to go back to school?

Tausi: Hmm . . . It was tough [laugh and sigh]. Well, I decided I wanted to go back to school. He didn't like it but he didn't have a choice because I had made up my mind. [He had] the feel-

ing, you know, that I am moving up because he mentioned "there is a gap between us" and so I suggested to him . . . why don't you apply and do some correspondence courses with the hope that it will try to bridge the gap. He never did it.

Mumbi: Can you think of an example of what makes you think it was tough?

Tausi: I remember being made to feel guilty about the kids—he made me feel guilty about leaving the kids. Fine, I left the kids. I wish I can be there with them but I can't. But I think I am doing something good for them. You know, it is not just about kids . . . but the big thing is about them.

At this point in Tausi's struggles, the conflict was mainly with her husband. The power struggle was evident between Tausi and her husband, based on the societal standards of who should be successful and who should not. It appeared that Tausi's husband was not willing to be nudged forward but rather wanted to "remain bullishly steadfast in [his] devotion to the status quo."[25] On the other hand, Tausi was defiant about her decision to go back to school. The fact that she felt that her husband ". . . didn't have a choice because I had made up my mind" displayed an adamant attitude that was not typical of her position as an "African wife." Eventually her husband remarked "there is a gap widening between us." This situation marked the beginning of a power struggle that continued throughout Tausi's narratives describing her married life. Tausi had, at this point, no hope of bridging the professional gap between herself and her husband.

In her narrative, Tausi goes to on show how the conflict encompassed the children as well. Tausi's children were young. She had always been near her children and this was the first time she was contemplating leaving them behind. The phrase "it is not just about kids . . . but the big thing is about them" is an indication of Tausi's tension in trying to understand her situation. The issue of altruism or greater good of the family seemed to be very intense in Tausi's reflective narrative. In trying to reconcile her feelings about having left her children behind, she contended that "I wish I was there with them. But I am doing something good for them." Although Tausi talked about seeking education for personal em-

powerment she, at the same time, talked about seeking education for the good of the family. She also saw this opportunity as a chance to be a role model for her children who were growing up.

Evidently, the need for both her personal empowerment and altruism presented a paradoxical situation not only for Tausi but other women as well. As women embraced the chance to improve and empower themselves, they also saw this as an opportunity to eventually provide better lives for their families, advance their careers and become role models for their children and other women as well. Thus, although altruism and personal empowerment had a conflicted relationship, many women found it difficult to explicitly separate them because together, empowerment and altruism formed a dynamic that touched the core of what it was to be an educated African woman. For example, in most African social contexts, success of any educated mother was rated in terms of how much she provided for her children materially and in identifying windows of opportunity for her children's advancement in life. We saw how powerful this internalized belief can be in shaping women's lives through Tenji's affirmation of the desire to be "selfish for the first time." It is no wonder that African mothers' aspiration for their lives often includes that of their children, too.

However, the extent to which empowerment or altruism becomes the dominant aspiration depends on the emphasis given by individual women based on the value system that govern each woman's life. Tausi was in conflict with her husband because he didn't seem to appreciate the intensity with which Tausi upheld altruism as the reason for her sacrificing to leave her husband and children behind. He did not think Tausi's leaving the children for further education abroad was good because he had different values. The fundamental question is why does there seem to be a difference in perception of what is good for the family between the two people who formed the relation in the first place? Who decides what values are paramount in making such decisions that will affect the family?

Tausi's struggle with the conflict between altruism and empowerment developed into a sense of frustration as she emphatically tried to resist the feeling of guilt as it related to the virtue of motherhood and domesticity. This conflict is also extended to her values of education, her values about marriage, and mothering. Often many African women end their struggle for empowerment and education when hopelessness and

guilt overwhelm them, thus reinforcing gender stereotypes and material reality of women in "powerless and marginalized supportive positions."[26] However, women's marginality, through conscious raising and naming the source and consequences of marginality in their narratives, can be turned into an advantage as it offers the "necessary conditions for resistance and transformation."[27] Such narratives go beyond masking the "conflicts women face living under patriarchy" and move towards liberating women from "cultural silence."[28] Tausi was not willing to give up the struggle: She persisted.

RESISTING SUBMISSION: SPEAKING THE HOME CONFLICT

Tausi's previous narratives attested to her cultural resistance by speaking through her conflicts. Cultural silence, as used in the African context, is a sign of submission. I see submission as a descriptor of a gendered differentiated power relation between men and women. In their article, "Margins of Exclusion," Martel and Peterat describe the basis of women's submission and subordination:

> Each day of our lives we are informed that women do not count, that we are wrong, that our different descriptions and explanations are ridiculous or unreal. If we try and insist on their validity, we can be discounted again, as aggressive or emotional (unfeminine or feminine, but either is wrong).[29]

African culture expects women to be submissive because submission is an attribute of femininity. But often, women get so "cocooned" in their efforts for submission that they lose their own sense of selves. Through Tausi's narrative, it was evident how the concept of submission was in conflict with her other identities as the government representative and the head of the agricultural department in her country in Africa.

Mumbi: I would like you to reflect on your life and talk about the concept of submission in African women's lives.

Tausi: You know at work, I am different than at home. I am not submissive. I am [a] very strong person, having been able

74

to succeed in agriculture, which is male dominated. But at home I am a different person. I have to let go of many things. I have to pretend I like it. I have to say its okay even when it is not . . . when I am hurting myself and, yes, at home I was very submissive but I am different now.

Mumbi: Are you saying that women tend to condone things simply to avoid conflict?

Tausi: Yeah! But even law treats us differently . . . the wife is a minor. There are things that my husband can do and I can't. My husband can sell a house without my consent. But I can not go to the bank and get a loan on our property. He can go to the bank if he wants without consulting the wife. So this is our culture—that allows such things to happen.

Tausi identified herself with the rest of the women when she said, " the law treats us" as minors. She accepts that she belonged to this category because, despite her education, there were things that her husband can do simply because he is a man. For example, to get a bank loan in Africa, she had to get her husband's consent even when she was earning more than he was. At the same time, Tausi saw herself as a successful administrator working in a male dominated field and succeeded in getting things done. Yet, at home, she had to be a submissive wife by letting things go and pretending that all is well.

Tausi's analysis of this family situation revealed that at one time and in a specific context, Tausi described herself as submissive. However, looking at the decisions she had made about going back to school, such decisions would not be possible in the context of submission. What then is it to be submissive? And, in what situations can one claim to be submissive? I interpret this situation as a moment in which Tausi rebelled against the gendered restrictions and made decisions based on her own reconstituted values of who she was and what she wanted to be in life. Feminist theorists of resistance contend that resistance has different meanings and that women can resist domination and oppression by negotiating social forces and possibilities in an attempt to meet their own needs.[30]

For Tausi, letting things go and pretending things are okay is to me a negotiated stance and not necessarily a sign of weakness. Sometimes

in a relationship, one has to compromise, but not for something that is so important. Tausi's values of education and self-improvement, though in conflict with those of domesticity, were negotiated to become paramount in her decision to come to the United States for further studies. In reminiscence of the societal prohibitions and restrictions, taking this stance was not easy. Tausi observed:

> Some people will look at you and say I don't know whether I will be able to do it. Especially leaving home. Some people will not want to leave their families and go somewhere. So it is a big step.

Acting on such decisions, as Tausi has demonstrated, requires a radical or a strongly convinced individual bold enough to venture into such ideas and to deal with the consequences of such decisions. Sitting in her apartment in the United States, Tausi was aware of the consequence when she said that her "greatest fear is that I will be alone. That I will have no marriage." But despite her tears she concluded, "that is something I will have to deal with" when she goes back to Africa. From a feminist perspective, Tausi's decision to "deal with it" holds, as it were, "the seeds . . . for a better future for herself and for women more generally."[31] When women acknowledge their constraints and make conscious decisions to deal with them, those decisions empower them to act. True to what Miles says, "women discovering their personal potency and by extending their use of power, changing its nature, is nowhere more encouragingly expressed than through the lives of women who found themselves."[32]

As we wound up the interviews and discussions, there were no better words to sum up the essence of this study and the envisioned process of emancipating women than in Tausi's words about silence.

> I think we have to make the womenfolk learn to talk about things—our experiences. The silence is the thing that weakens us. We don't get to know that other people are going through the same situations and so we don't get to hear that there are possibilities and other options. We have to be willing to talk about things. Put them up in the surface and talk about them.

By speaking openly about her conflicts and worries, Tausi trespassed the cultural boundaries that defined women's cultural silence. I am reminded of an African popular saying "that which belongs to the homestead or home should forever remain within the homestead." This means that one should not go about talking in public about private family issues. To name such cultural beliefs and to speak about the hegemonic patriarchal undertones that work to keep the women silent about their experiences become positive moves towards liberation of womenfolk. Talking about our experiences and sharing among ourselves, builds what Durkheim calls "mechanical solidarity."[33] Mechanical solidarity holds that similarities or commonalties in a group become the main bond that binds people together into an exclusive relationship. This is, indeed, a representation of what DuPlessis, as quoted by Bloom advises: that women "make conflicts that emerge from their marginalized status and their rebellions against marginalization central to their stories."[34]

CONCLUSION

This narrative portrayed a painful trajectory of Tausi's determination to break through African cultural patriarchal confines of domesticity and venture into her unexplored life outside of the home. In her articulation of her subjective positions as a wife, mother, and professional woman, Tausi was able to move beyond the confines of domesticity and to see options available to her. Moments of conflict also put her in a position where she could radically call to question those cultural beliefs and values embedded in domesticity that were oppressive to her and to other women. This radical position of reflexivity as she watched her life-history as a "movie" made her, not only see things differently, but become different and (using her words) "mature." It is within this frame of mind, when we question what we have always taken for granted, that transformation and emancipation is possible. There are those like Tausi who will take the brunt of pioneering by choosing education over domesticity, but, I believe, their action will raise critical consciousness that will mobilize other women towards participating in whatever action necessary to not only change their lives but society as well. These are the harsh but liberating facts that we, as African women, have been enjoined from recognizing.

77

Notes

[1]Rich, 1979, p. 215.
[2]Luttrell, p. xiii.
[3]Roger and Freiberg, 1994.
[4]Andersen, 1983; Shreve, 1989; Bhalalusesa, 1998.
[5]Shreve, 1989, p. 9.
[6]Shreve, 1989, p. 69.
[7]Otieno, 1998.
[8]Otieno, 1998.
[9]Rosalind Miles, *Women and Power*, 1985, p. 177.
[10]Miles, 1985, p. 41.
[11]Luttrell, 1997.
[12]Luttrell, 1997, p. 85.
[13]Kenyatta, 1962.
[14]Kenyatta, 1962.
[15]Hay and Stichter, 1995.
[16]Sidel, 1990.
[17]Shreve, 1989, p. 132.
[18]Shreve, 1989, p. 217.
[19]Martel and Peterat, 1988, p. 161.
[20]Harding, 1987.
[21]Bloom, 1997.
[22]Bhalalusesa, 1998.
[23]Miles, 1985, p. 177.
[24]Bhalalusesa, 1998.
[25]Shreve, 1989.
[26]Martel and Peterat, 1994, p. 154.
[27]Martel and Peterat, 1994, p. 154.
[28]Bloom, 1998, p. 74.
[29]Martel and Peterat, *Margins of Exclusion*, 1994, p. 158.
[30]Munro, 1998.
[31]Bloom 1996, p. 185.
[32]Miles, 1985, p. 177.
[33]Collins and Makowsky, 1994, p. 106.
[34]Bloom, 1998, p. 183.

Chapter Four

"Unless We Are There, Nobody Is Going to Speak for Us": Tenji's Story

Quietly, unobtrusively and extremely fitfully, something in my mind began to assert itself, to question things and refusing to be brainwashed, bringing me to this time when I can set down this story. It was a long and painful process for me, that process of expansion.[1]

My first interview with Tenji was a very informal one. Aware of the intricacies of "entering the field,"[2] I did not push to talk about the details of her life experiences at this point. Rather, we spent time talking generally about the importance of education, about how our children needed to take education seriously, and about the long and arduous journey we have traveled to get to where we were as educated women. Our initial conversation was spontaneous and very engaging and we seemed to put the blame for most of our internalized painful experiences on the patriarchal society within which we were raised. Although Tenji might not have completely understood the power underlying our words that day, I knew that we had started on the road to deconstructing the legitimized societal way of life that had worked to define and set limits to what we could do and become, as African women.

My interview with Tenji took place at her home in rural Africa. We were out on her five-acre yard adorned with beautiful lawn and ornamental trees planted ten years earlier through a rural afforestation campaign project. We had identified and settled on this spot because it ensured little disturbance from her energetic four-year-old son. This spot also provided a beautiful panorama with the skyline touching the earth at the horizon, accented with undulating hills of the countryside. In retrospect, this panorama might have been signifying the possibility of the two worlds: the patriarchal world and the world we hope to reinvent as women, coming together someday.

This chapter presents an interpretation of Tenji's narratives. The first theme is based on Tenji's statement about being selfish for the first time. She articulates how she wrestled with the feeling of being selfish for having made the decision to leave her family to pursue further education abroad. The second major analytical section focuses on Tenji's use of the metaphor of a "package" to describe her understanding of the family and how she finds the family package problematic. The last analytic section demonstrates Tenji's perception of what it means for an educated African woman to desire to use her skills and still find herself stigmatized as a deviant within the male dominated educational environment.

"BEING SELFISH FOR THE FIRST TIME": REDEFINING THE SELF AND THE SELFLESSNESS

Despite the difficulties African women face trying to address their social position and identity within the African society, it is interesting to see how Tenji, through her narratives, tries to articulate and understand herself within the conflicting discourses of domesticity and education as an educated African woman who is also a mother, and a wife. At this point in her career, Tenji holds a faculty position at Bora University after having returned with a doctorate. She is reflecting back to the time when she was making the decision to go for higher studies abroad. Unlike many African women, Tenji is daring to venture into an area where few women have dared because of the fear to challenge the familiar world: She is dar-

ing to define herself in her own words. Her style of self-narration reflects a unique perspective about how she views herself and her situation. This unique style of self-narration is evident in her response to the question about how she felt about leaving her family to go abroad.

> **Tenji:** It called for boldness. This time was a question of feeling and looking forward and saying I am capable, I have a chance . . . also being adamant enough and saying this is what I want to do with my life. You know . . . being adamant and putting your . . . [pause] your . . . [pause reflexively] like putting what is yours up-front and being selfish for the first time. Being able to put forward your ideas and to look into your future and seeing where you want to go.
>
> **Mumbi:** Could you please elaborate.
>
> **Tenji:** You know . . . I knew I wanted to be a university lecturer. I wanted to be able to compete for any position on that establishment and a doctorate was at least a step in the right direction. Leaving my children and my husband behind was not easy but again you have to keep quiet and think . . . kind of compartmentalize your life, so you can also have a compartment—you have a space and then you look at your space, where it is and where you want to go . . . because when you look at the family as a package, you always end up disappearing without appearing anywhere. So I was able to do that.

I remember vividly the pensive mood as Tenji spoke these words. Soon after, the pensive mood was juxtaposed with Tenji's obvious sense of accomplishment and self-pride. I was captivated by her demeanor: Why was she so self-consciously proud of her accomplishment? Several key words stand out and point to the possible source of Tenji's pride as she spoke about having had to leave her children to go abroad. Words like "capable," "chance," "adamant," look into your future, are in contradiction with what the society describes as "true" characteristics of African women. According to England, the traditional society and patriarchal cultures see a woman as a signifier of the male "other" bound by a symbolic order in which men can live out their fantasies and obsessions . . . by

imposing them on silent image of woman still tied to her place as the bearer of meaning, not the maker of meanings.[3]

Feminists have argued that male domination is encoded in the language and images that devalue and silence the feminine.[4] Arguing that such systems of meaning making can be contested and subverted, feminist post-structural theorists persuade us to see language as a site of struggle rather than a neutral means of expression. As it is the case with women in Africa, their silent images are definitely not described by the words "adamant," "capable," "upfront," which Tenji uses to describe herself. These are words and phrases that describe male characteristics. By using these words, Tenji is expressing an experience that contests the adjectives that characterize women's identity. In the realm of domesticity within the African culture, a woman is supposed to be submissive but not adamant, dependent but not independent, and selfless but not selfish. Why then should Tenji glow with pride as she describes herself in "male" words?

Tenji's ability to see herself as capable of pursuing higher education does not reflect female characteristics of passivity or dependency, but reflects boldness and a tremendous sense of self-worth. Having already successfully completed her first degree and a master's degree, she is now looking for an opportunity to do a doctorate. It is not surprising, therefore, that Tenji's achievements as a woman are vital as they mark the beginning of a process of challenging the structures that shape her life as a woman. For her to use masculine words to express herself speaks to and problematizes the patriarchal masculization of language that deprives women the means to express themselves as women.

Problematizing masculization of language helps us to recognize attributes like adamant, which are understood and expressed from a masculine perspective. This recognition reveals, to an even greater extent, Tenji's struggles, frustrations, and inhibitions in her attempt to define herself using male-defined characteristics. Transcending the male-defined female characteristics and taking up male defined characteristics become her major source of pride and, speaks once again, to the patriarchal definition and meanings attached to the male and female identity within the African culture. Tenji's sense of pride is also manifested through the affirmation of her decision to be "selfish for the first time." This was a radical statement given the fact that motherhood or domesticity is believed to be synonymous with selflessness.

The notion of *self-less-ness* of women is not unique to African women. Gender socialization, in many cultures, affects the selves women are or are not. However, the *self-less-ness* experienced by African women is different and has direct implications for the extent to which African women are able to appreciate self-actualization and disclosure in their lives. Compounded by the limited choices women have to realize their potential and to vocalize their inner yearnings, fears, and suffering, self-less-ness has made African women's self-image cloudy to themselves and to others. Tenji's desire to be *selfish for the first time*, therefore, points to the dire need for African women to uncloud their image.

Before I discuss the issue of "self" further, I want to clarify my use of hyphenated *self-less-ness*. The opposite of selfish is selfless or generous. I wish to argue for a different meaning of *self-less-ness*: the meaning that denotes an absence of "self" and hence self-less. The concept of *self-less-ness* is important in understanding African women's cloudy image because it puts the issue of the "self" at the core of any feminist scrutiny and critique of the African culture. Tenji's notion of being "selfish" does not necessarily mean being conceited or self-centered (although this could also count as true), rather, I see her wanting to be selfish as a conscious desire to re-invent herself by changing the focus of her identity from that of someone forever "keeping the others afloat . . . or helping others."[5] As Krieger rightly puts it, if, as women, we ignore the process of self discovery and we only acknowledge the forces that effect who we are and what we know, we ignore the full reality that informs our being. Tenji's strong desire to change the focus was, therefore, 1) an act of resistance to the traditional norms of domesticity, 2) a desire to be independent and, 3) a means to recreate her own identity.

Another aspect of *self-less-ness* of African women is worth mentioning here. In many African traditions when a woman is unmarried, she is her father's daughter. When she gets married, she becomes the "wife of so and so" and when she bears her firstborn child she "abandons" all her other names and, henceforth, adopts the title of the "mother of so and so." However, in cases where the first born is a girl, and the woman later bears a son, many people prefer to call her the mother of the "son" because being a mother of sons or male children accorded women added honor. It follows, therefore, that African women's identity has always

been constructed in relation to other people within a social group. When women's identity is constructed in relation to fathers, husbands, and children, the self is not only blurred, but often times erased. Further, when women accept and internalize this relational definition of their self, it becomes, in itself, a form of self-erasure.

Although African patriarchal kinship bestows maternal honor to mothers through the assumed title of "mother of so and so," critical cultural feminist theorists would see this as a male plot that works to keep women in their place as mothers and nurturers. The notion of the "maternal honor," therefore, becomes a masked and falsified privilege that disguises women's dependency on patriarchy for approval and survival. As many feminists rightly point out, women learn only to see themselves through masculine eyes or the "male gaze."[6] In the book, *On Lies, Secrets, and Silence*, Rich too articulates the notion of motherhood as a political institution and a site of domination of women by men. She contends that "[only] when women recognize and name as force and bondage what has been misnamed as [motherhood or marriage], we [shall] begin to love and nurture out of strength and purpose rather than out of self-annihilation."[7]

I see motherhood and marriage as fundamental feminist issues with a dire need for serious activism within African culture. Activism will help create spaces for women to discover, name and re-define themselves using the language of resistance in ways that "explode male discourses."[8] My belief is that Tenji's motives and actions are an indication of a conscious understanding of the need to re-define herself and to create the new woman she truly believes she is. "Being selfish for the first time," therefore, is an affirmation of this intention and a challenge to the taken-for-granted notion of self-less-ness embedded in motherhood and validated through the ideology of domesticity. This conscious understanding of the need to create the woman she really is explains why Tenji was glowing with joy, pride and satisfaction for her academic achievement and for the independence of thought that enables her to challenge the taken-for-granted, familiar world, and to affirm her redefined identity.[9]

Tenji's perception of "selfishness" as a crucial standpoint in the process of creating a new woman and a new self is familiar to me. It resonates with reflections on my own experiences of transformation from self-less-ness to "selfishness" as I struggled to come to terms with my absence

from my family through my decision to come to the United States to further my professional and career development. Having taught college in Africa for about five years, it seemed inevitable to seek a higher degree necessary for promotion in the academic career. And, because the university was experiencing financial difficulties and planned to reduce the size of the faculty, having a doctorate would offer the needed sense of job security in the future.

Consequently, I developed a sense of uncertainty about myself and doubted the validity of the decisions I had made. This uncertainty haunted me throughout the time I was getting ready to come to the United States. I was tense, frustrated, and uncertain about myself. As a woman who had struggled to live up to an internalized image of the "good mother," I was trying to fend off the depression, anger, and uncertainty that threatened to overpower me as I felt my sense of self slipping away. I felt guilty for leaving my children behind, and for a long time I experienced a nagging urge to constantly justify my decision to come to the United States.

However, through my exposure to feminism (which I have studied and embraced), and to various contemporary critical feminist theories, for example, critical cultural theories, critical race theories, identity theories, to mention a few, I began to think more reflexively and to search for my "self." Searching for myself, through self-scrutiny and interrogation, did not only foreground the effects of the decisions I made to come to the United States, but also, the underlying dynamics of the decision-making process. I identified the forces that were at play at that time and which may have influenced my decisions to come for further studies. I realized that the mind-set within which I articulated and justified my coming back to school had changed tremendously over time. Although promotion and job security remained as the basis of my justification for my decision to come back to school, I no longer saw them as absolute. The more I searched for my self, the more I realized that these initial reasons had very little to do with my coming back to school. I now believe that the fear of retrenchment and lack of promotion were superficial reason and that there were other underlying forces that were at work, though invisible and unknown to me at the time. I craved for space—social, academic, political—some space, any space. But it was difficult to define or even understand this craving. Could it have been a craving for "selfishness"? But, again, how could I, as a mother, ever think of being selfish?

"Selfishness" which Tenji and I (as well as Tausi and Tamara) have reclaimed gave access to various forms of agency. First, selfishness helped us to see ourselves not as mothers who sacrifice themselves and suffer on "the cross of motherhood," but rather, as mothers who count their "selves" in, mothers who have value, mothers who are smart enough to seek an education. I see Tenji's use of the word "selfish" as a way of reclaiming it to mean boldness rather than conceit. I also see the word "selfish" constituting a mindset that will help African women rethink education and domesticity, not as oppositional ideologies, but complementary. In its reconstituted meaning, "being selfish" will no longer be a word that conjures up shame and guilt of choosing education over domesticity, but a word that will bring pride, joy, and satisfaction. By being "selfish" women will experience their "presence" rather than "absence" in every aspect of their lives. This is, I believe, the craving I experienced, and the reclaimed sense of "selfishness" has given it meaning.

But this transformation process of accepting to be selfish or being at peace with choosing education over domesticity, should not, by any means, be seen as an easy achievement for Tenji or myself or other women. In the edited book, *Women in Cross-cultural Transition*, Bystydzienski and Resnik, note that "emotionally, cultural changes may be more difficult for women, because they are socialized to 'feel' their way in relation to others and the world while men learn to suppress emotions."[10] This transition involved arduous and painful but transformative experiences of, at first, emptiness and hopelessness as we uprooted the internalized cultural norms and expectations of domesticity. Accepting to be selfish for the first time was a painful and disorienting process but also empowering in the hope that "beyond the issue of . . . motherhood lies the implacable political necessity for women to gain control of [their] lives."[11] And yet, being selfish does not necessarily lessen the oppositional pull between domesticity and education. Rather, it allowed us to become a part of this oppositional discourse, consciously, with the hope that this engagement will bring forth change, not only to the lives of African women, but to the society as well. We do this for ourselves and for each other, with a "hope for a future in which human existence will no longer be ruled by hypocrisy and force."[12] This must be the desire of every woman in African, educated or uneducated.

THE UNREAL FAMILY PACKAGE

Tenji had been away from her family for a period of four years. During this time of separation she questioned the rigidity and the reality with which she had assumed her roles as a mother and a wife. She also reflected on the extent to which she had believed that her family would not function without her. One of the most profound statements that Tenji made during my interview with her was about how she viewed domesticity and her role as a mother and wife after returning home to Africa.

Mumbi: What changes did you see in your roles as a mother and a wife after coming back from abroad? If you had the same chance would you do it again? How is your life now that you have come back?

Tenji: Having come back—if there was more to do I would still do the same because when you leave [to go abroad] what you realize is that the family package that you are loaded with as a mother and a wife is an imaginary one. These people can survive without you as they would survive if you were dead . . . I am right now looking for a chance to go away on my sabbatical leave to promote myself because nobody else is going to do it for me.

Tenji uses the metaphor of a package to describe her new perception about the family. The statement about the family as a package is as ideological and political, as it is practical. The metaphor of a "package" denotes cultural rules and regulations attached to domesticity, in general, and to the marriage institution, in particular. Cultural rules wrapped up and bestowed in marriage in form of a family "package" worked to control and regulate functions and relationships within such institutions. Because womanhood is culturally constructed in relation to domesticity, and women are viewed to be the custodians of culture, these rules and regulations are directed to women rather than to men. The depth of Tenji's perception about the family package cannot be adequately appreciated without understanding marriage in an African context. From very early in life, girls are socialized to become wives and mothers. Girls, therefore, grow up idealizing marriage as the ultimate

and honorable destiny. Failure to get a husband is the worst form of rejection any woman would experience and it was not only a dishonor to her but also to her family and clan. The most important moments in a traditional African marriage were the days before the wedding. Older women would spend time with the girl during this period teaching her about her new roles. As I reflect, now, after many years of marriage, on what was told to me personally before I married, I can not help but be angry and resentful about my internalized beliefs and expectations about marriage. I see in the older women's role as marriage "counselors," forces that collaborated with the patriarchy to perpetually get women into the marriage trap. The family package bestowed through marriage, therefore, was not about the benefit of marriage to the girl, but rather, what the girl becomes after marriage—a woman, a wife.

Another way to see marriage is to look at it as a way of appropriating surveillance over the girl from her father to her husband. A common feature in the traditional marriage within the Kikuyu culture, is when a mother gives her daughter all her belonging—including the bed—to signify that she had no place to come back to should she decide to leave her husband. A wife belongs with her husband and she has no right to be anywhere else. This expectation is internalized to a point where women believe that being away is morally wrong and so women never go anywhere. Consequently, for a wife to be away for any reason from her home, husband, and children is unfathomable in the African familial context. Therefore, the family package that Tenji is talking about refers to all these rules, regulations, and expectations, perpetuated and validated through culturally legitimized discourses that infiltrate the lives of African women.

To understand the concept of family package as a form of power, I draw on Foucault's discourse on discipline and punishment.[13] According to Foucault, discipline is "a type of power, a modality for exercise, a whole set of instruments, techniques, procedures . . . to assure that discipline reigns over a whole society (the police)."[14] But what is significant about the discipline and power that Foucault talks about is that although the mechanism and the instruments are visible, the power itself "insidiously objectifies those on whom it is applied; to form a body of knowledge about these individuals, rather than to deploy the ostentatious signs of sovereignty."[15] Because this form of discipline is not perceived as coercive, its power is always misconceived and underrated. In the African patriarchal traditional context, for

example, the family package is a means of reinforcing or organizing internal mechanisms of power to ensure a disciplined marital, familial, and kinship relationships. As women believe and live these roles, the family package becomes "real" to them because it is what they do everyday. Similarly, the family package becomes real to men, also, because women are there to take up and affirm those roles as women's roles.

In exploring the internal mechanisms of power, I draw further from Foucault's notion of panopticon, a generalized mechanism of discipline and surveillance that infiltrates all other power structures. As a strategy of surveillance, panopticism likens society to a prison where windows are strategically positioned points of surveillance and "each gaze would form a part of the overall functioning of power."[16] In this case the society as a prison affirms and polices discipline through established network of social apparatuses that make up the "social gaze." Panopticism, within the African traditional context, can be understood as a generalized mechanism of surveillance that infiltrates all other power structures and brings the effects of power to the minute elements of social context as in the family package. The effectiveness of panopticism as a mode of discipline in African context is, therefore, in its multiplicity of family package as decentralized pockets of power within the clan, tribe, family and local community. The family package as Tenji portrays it is so normalized that the coercive power is unrecognizable but the surveillance, therein, is effectively and constantly maintained, even by women themselves. Further, the family package as panoptic surveillance is given a respectable and moral face perceived to be necessary for ensuring a strong foundation for the society. Because motherhood is glorified as a sacred and noble duty on which the society depends for survival and appropriation of its culture, women feel morally obligated to uphold, rather than abandon, motherhood despite its oppressive demands on their lives. And because the surveillance, thereof, is so naturalized, women conform by taking responsibility for observing the rules and often imagining the gaze even when it is not there.

The family package defined who Tenji was as a woman and she observed her roles "unselfishly." The roles designated by the family package were to her the "Truth" about how the society worked and what tied it together. After all, wasn't selflessness through domesticity what being a woman, a wife, and a mother was all about? But when Tenji left to go

89

abroad and stayed away for three years to complete her degree, she was able to observe the family package outside of the familiar context. She realized that outside of the societal surveillance, these roles were no longer effective; they were no longer real. Because she was not at home in Africa enacting the roles of domesticity, Tenji argued that those roles were no longer binding because the panopticism or the social gaze was only effective within the panoptic vision. She observed that as she moved out of this panoptic vision, the surveillance was no longer effective and, therefore, those roles ceased to be real to her. Tenji's concept of the "unrealness" of the family package is important in revealing the fact that while motherhood and domesticity are important parts of women's lives that engender honorable status, it is imperative to also recognize that motherhood and domesticity are potentially oppressive cultural concepts inscribed in the ideology of domesticity.

According to Tenji, the fact that her family continued to function unabated, "falsified" the reality of those beliefs and attitudes to which she had clung for so long. It also reveals how domesticity as a patriarchal social construct needs subjective women to play these roles and to sustain and authenticate its creation of reality about who women are and should be. Like Tausi, Tenji was able to look back at her life and question those cultural norms and values that defined her as a woman as well as the power structures that worked to ensure that those roles were adhered to.

While I agree with Tenji about the fact that moving away from the societal gaze affects the way we view our roles as mothers and wives, I do not think that moving away totally erases the societal gaze. To believe that moving away removes us from the societal gaze or the panoptic vision is to under-estimate the power of the internalized gaze that is imprinted in us throughout the socialization process. I recall many times, in the course of my stay in the United States, when I would be overwhelmed by thoughts about how my children were doing in Africa. I wondered whether they had enough to eat, or whether their school fees were paid, or whether the caretakers at home were treating them well. I even sometimes shopped for their clothes and waited to send them with anybody going to Africa. Evidently, in all these situations, I was constantly being effected by my internalized self-gaze about my role as a mother even if I was outside of the societal panoptic vision. The major effect of panopticism

according to Foucault, is the infusion of a conscious internal visibility or self-scrutiny and self-policing even when we are out of the optic vision. Therefore, the absence of direct gaze from the society does not necessarily obliterate the surveillance, but only makes it less annoying and repressive. For Tenji and me, the absence of the direct gaze gave us the sense of freedom that allowed us to concentrate on our studies. It did not, however, relieve us of our responsibility or concerns as mothers because our internal gaze was effective within us.

The notion of surveillance, notwithstanding, however, Tenji's contention of the family package as "unreal" exposes the insidious and coercive power of African traditions and the effectiveness of the patriarchal structures to police cultural traditions in women's lives. The insight about the "unrealness" of these roles is not only important for redefining domesticity for African women, it is also important for demystifying cultural construction of motherhood and domesticity in order to release the cultural grip on women's lives. The logical argument is that if the family package becomes unreal as soon as women get out of the cultural and societal context, then it should not be used to hold women forever in those cultural binds. Consequently, the concept of "unrealness" should be embraced as a form of a critical space from where African women can question and challenge those cultural definitions that have been made to appear so real, thus making it difficult for women in Africa to achieve their goals outside of the home, among which is education. This analysis of the family package as a cultural construct helps to illuminate, further, the society's perception of an educated African woman as Tenji narrates her efforts to fit back into the society and into the university.

FITTING BACK INTO THE SOCIETY: TENJI'S PARADOX OF RESISTANCE AND CONFORMITY

In my interviews with Tenji, I was interested in finding out how she was fairing after returning home with a doctoral degree. Although Tenji was aware of the societal scrutiny to see what kind of a woman and mother she was going to be after having been away for so long, her major

concern was trying to fit back into the university. Educated women aspiring for high positions in academia are seen as a threat to the male chauvinism in most African universities. Breaking the stereotypical barriers in the university where the academic environment is unreceptive to educated women was going to be a major challenge that Tenji had to confront in her attempt to fit back into academia.

> **Mumbi:** Tell me your experiences after coming back with a doctorate.
>
> **Tenji:** For my work at the university . . . that is where the problems are. In fact where you do not expect problems, that is where they are most. . . . because with our kind of establishment where all those with doctorates are male, [my coming back] became a very big challenge to their administration. You are almost a "being" they cannot understand. Being a wife, a mother, and a scholar is something that makes them scared. That's what some of my experiences were.
>
> **Mumbi:** What kind of responsibilities did you get and what was the work environment like for you as a woman?
>
> **Tenji:** They want to keep you away as far as they can. They don't want to give you responsibilities that will make you challenge them. They don't want you to get close to whatever their circles are so they keep you out in many areas.
>
> **Mumbi:** So what are you doing about this? Are you seeking redress?
>
> **Tenji:** For now, I have not pushed and have not tried to force myself into any of that. I think I will wait for the opportunities to come.
>
> **Mumbi:** Are you saying that despite the problems you have gone through, it doesn't mean that when you go back you will be readily accepted in the academic circles?
>
> **Tenji:** Yeah . . . that's what I am saying. It is an uphill battle when you are a woman, a wife, a mother, and a scholar . . . because there is scrutiny from all quarters. The stereotype ideals for an educated woman are that—you are, first and foremost, a female, and that you should be divorced or single. So

when you are neither of those, they do not know where to place
you. . . . There is that scare. The problem is that if you are a
mother and a wife you are inaccessible and you do not fall in
the category of the "educated woman"

Tenji's responses to my questions portray a determined woman
who has her goals and ambitions up-front. She shows an incredible drive to
achieve and she ably fits the description of a strong woman. However, Tenji
is already dealing with the tensions in her identity as 1) a woman and a
mother within the expectations of the society, and 2) as a professional and
a scholar in her own right. Having redefined herself as a strong woman who
dared to be "selfish," and having falsified motherhood roles as imaginary
norms in her articulation of family package as unreal, one wonders why, on
returning home to Africa, Tenji talks about "working very hard to keep the
family together" through enacting the same roles constituted in the family
package which she strongly disputed. Further, why would Tenji, knowing
that she was qualified to teach at the university, say "for now, I have not
pushed and have not tried to force my self into any of that"? Why the con-
tradiction? Why does she say that she will "wait for the opportunities to
come instead of seeking them?" Why the passivity?

In reference to the concept of panopticism discussed earlier, when
Tenji is away, the direct societal policing of her family roles was less
effective and, therefore, she was able to recreate her identity as empow-
ered. She says that "the separation gives you a lot of time to think about
who you are, to think why you moved away. . . . It gives you a lot of time
for soul searching. You are able to define yourself." However, when she
goes back, the panopticon re-emerges. She becomes aware of the societal
surveillance and control once again as she says "there is scrutiny form all
quarters." Her sense of self-empowerment and the awareness of surveil-
lance present a paradoxical situation for Tenji. On the one hand, one can
argue that by enacting her roles and acknowledging of the re-emergent
surveillance and control does not necessarily mean that Tenji loses her
empowered self. Rather, because she already knows that these roles are
imaginary and that they are only enacted because of the cultural gaze she
is able to enact them without being bound by them. In addition, because
she had already recreated her empowered identity when she was away,

she does not rely on the oppressive societal definition of motherhood for her societal approval. Therefore, she can comfortably function in motherhood roles because she is aware of how such roles unleash their oppression on women. Consequently, it can be argued that to have power is not about choosing when or in what situation to act empowered, because you do not choose the situations. To have power is the ability to have choices to act in those situations. And because Tenji is making deliberate choices to function in the roles of motherhood, then those roles no longer have an oppressive hold on her as they did before the U.S educational experience. On the other hand, however, although Tenji claims that these roles do not have an oppressive hold on her, one might argue that despite her empowerment, the societal surveillance and control is so powerful so that she no longer has the energy to resist. In such a case it would be difficult to say whether her conformity is an act of empowerment of coercion and hence the paradox as to whether it is possible to have empowerment in a coerced conformity. This line of argument leads to the next section of my analysis of Tenji's experiences at the university.

Tenji's experience within the university context is depressing. As an educated woman in a male dominated educational environment, Tenji laments that she "become[s] a being they cannot understand." Her identity as an educated woman defies the male-defined attributes of femininity because education is not perceived as feminine and, therefore, her femininity is "suspect." Given Tenji's situation where her own identity is not only contested but questioned, pushing for positions at the university translates into yet another paradox with little or no options for her. She must decide either to give up her "femininity" and fight it out with the men, or to follow their rules because she explicitly knows the consequences of resistance. Further, her desire to be in administrative positions that would allow her to speak and effect changes for women becomes a very crucial part of the paradox. Tenji seems to have chosen to conform and this is why she appears to be contradicting her professed empowerment. She might have made the decision to conform deliberately by considering what might be in jeopardy if she resisted, or she might have been coerced by the limited choices and circumstances surrounding her position at this point in time. More importantly, the paradox and Tenji's situation raises questions as to whether or not one can talk of agency, empow-

erment, and resistance in the context of conformity. Is it possible for her to choose to function in a disempowered way and, at the same time, have agency and empowerment?

According to Norquay,[17] contradictory experience of both reproducing and resisting dominant norms and structures are key to the shaping of our actions. Norquay further reiterates that the acknowledgement of the interplay between the multiple layering of the subjective and the social in an individual's life is not only essential for analyzing the connections between submission and resistance, but also becomes the site from which emerges the transformative power. For Tenji, the contradictory experience is indicative of the ambivalent situation she is in. She is aware of how sexism is being played out at the university. She laments, "They want to keep [me] away . . . they don't want to give [me] responsibility . . . they keep [me] out." With this kind of environment Tenji is cognizant of the powers that be and of what might be lost or compromised if she resisted. The worst that could happen is thwarting her ambitions to stand up for other women by losing, altogether, the opportunity to negotiate should she be indicted. Evidently, her claim of empowerment is problematic. Her actions and decisions are, at times, made from an empowered position and at other, from a state of coercion. Consequently, deciding not to push for the opportunities could be both a rational choice as well as an act of coercion. Nonetheless, even in these times of ambivalence, Tenji draws her strength and sustenance from her identity as an educated woman. She draws her strength from the fact that nobody can take her education away from her and that her promotion is just a matter of time. She says, "I am capable and my papers prove that. Time will come when they will let me operate in those areas where they think I shouldn't be." Given the multiplicity of contradicting realities of Tenji's position it is possible for her to show resistance in conformity in order to deal with her situation. Further, Tenji's status as an educated woman not only authenticates, but also allows for her acts of resistance in conformity because education is a recognized source of power within the university. If Tenji did not have a doctorate she would not have the power to resist in conformity. Ultimately .what Tenji seems to be fighting at the university is not whether or not she is qualified to hold administrative positions. Rather, she is fighting the patriarchal, sexist notion of being a "woman with educational qualifications"— being an educated woman in a predominantly male educational environment.

Tenji's other description of how "educated women" are defined is a disturbing reality especially in an educational setting. Educated women are stereotyped and stigmatized as deviants. Tenji observes that the stereotype of educated women is that they are either "single or divorced . . . if you are married, you are not accessible and you do not fit in the category of educated women." In the anthology entitled *Women, State, and Ideology: Studies from Africa and Asia*, Afshar[18] discusses ways in which being an educated woman in Africa is thwarted by ideological fears expressed in various patriarchal discourses. The three fears include: 1) the ideological fear of women who are not clearly confined to the sphere of domesticity; 2) the ideology that working women are symbols of corruption and agents of moral disintegration; and 3) the ideology of control of women and their sexuality which equates such control of women with social morality and harmony. These ideological fears become a form of power that legitimizes patriarchal discourse as valued cultural norms to be obeyed and recognized. In other words, the ideological fears constitute "cultural capital"—a form of cultural currency—that transforms power relations into legitimate authority.[19] The implications for the ideological fears on women's lives are clear, particularly in Africa. They do not only limit the educational opportunities available to women, but have covertly remained invisible to the national educational policy makers.[20] Consequently, the invisibility of ideological fears translates into a glaring disparity and a mis-match between the general nation-state policy on women's education and its application and implications for women. In addition, the way educated women are viewed in society, as Tenji mentioned, can be attributed to the influence of the ideological fears. Educated women are stereotyped and stigmatized as deviants. For a long time, educated women have been associated with being single, professional, and independent of men. In her study, *Women's Career and Professional Development: Experiences and Challenges*, Bhalalusesa documented some implications of the ideological fears on educated women's identity:

> My career means a lot to me. But at the same time it limits my chances of getting a life partner. In my country, men have the mentality that highly educated women are proud and feminists. People look at me as an ambitious academic woman. They do

not see what I was struggling for. In my society, I am a failure!
I am not married. I have no child My traditional society
respects a married woman and a mother.[21]

These narratives resonate with Tenji's observation that the men in her uni-
versity did not know how to define her because, although she was educat-
ed, she was married and, therefore, she did not fit nicely into the stereo-
type of the educated women.

In the book, *Women and Deviance: A Sociological Perspective*,[22]
Schur defines deviance as a way of characterizing that which is not in line
with the set rules and regulations of a social group. Deviance is a social con-
struction, which means that the behaviors of any deviant individual are not
intrinsically deviant but rather, they acquire deviancy through the societal
process of attaching meaning to that behavior. That the educated women are
stereotyped as deviant or "other" because of the cultural attitudes engrained
in the societal construct of an acceptable woman becomes, in itself, a form
of marginalization and alienation. But the concept of deviance should not
concern us only in how it implies marginality or "otherness" (although this
is also important). Rather, it should point us to the realization of the magni-
tude of the social control on women who want to be different. According to
Schur, the efforts to define deviance reflect specific kinds of threats to spe-
cific social positions or interests within the society. This perspective is rele-
vant to Tenji, Tausi, and Tamara's situations as portrayed in each of their
interpretive chapters.[23] By transcending the boundaries of domesticity, they
pose a threat to the African tradition, not only at the family level, but also at
other levels within the patriarchal societal structures. As their narratives
show, their strength in confronting, negotiating, and resisting such a hostile
society is in their "gaining" themselves and in asserting their new identity
which becomes a catalyst for emotional, psychological and ideological trans-
formation. As Weedon posits "resistance to the dominant at the level of the
individual subject is the first stage in the production of alternative forms of
knowledge"[24] I argue that it is this kind of transformation that is capable of
reformulating educated women's marginality as a locus of power to change
the society. This challenge is enormous. But, as Tenji rightly observed at the
close of our interview, "unless we are there, nobody is going to speak for us;
nobody is going to make a change for us."

Notes

[1]Dangarembga, 1988, p. 204.

[2]Van Maanen, 1988.

[3]England, 1993, p. 205.

[4]Smith, 1987.

[5]Krieger, 1991, p. 45.

[6]See, for example, Bloom, 1998.

[7]Rich, *On Lies, Secrets, and Silence*, p. 216-217.

[8]Bloom, 1998.

[9]Bloom, 1998.

[10]Bystydzienski and Resnik, *Women in Cross-cultural Transition*, 1995, p. 4.

[11]Rich, 1979, p. 221.

[12]Rich, 1979, p. 222.

[13]Foucault, (1977) 1984.

[14]Foucault, (1977) 1984, p. 206.

[15]Foucault, (1977) 1984, p. 209.

[16]Foucault, (1977) 1984, p. 189.

[17]Norquay, 1990.

[18]Afshar, 1987.

[19]Collins and Makowsky, 1998.

[20]Kiluva-Ndunda, 2001.

[21]Bhalalusesa, *Women's Career and Professional Development: Experiences and Challenges*, 1998, p. 29.

[22]Schur, *Women and Deviance: A Sociological Perspective*, 1984.

[23]Schur, Women and Deviance: A Sociological Perspective, 1984, Chapters 3, 4, 5.

[24]Weedon, 1987, p. 123.

Chapter Five

"In Control of My Life and Destiny": Tamara's Story

As the [women] travel, study and work abroad, they see new patterns emerging and they face new issues at home. No longer is their [vision] domestic only . . . they bring a broad perspective to their work . . . their problems may be African but these [women] put them in global perspective.[1]

Tamara came to the United States for further studies in the early 1980s. She is between fifty and sixty years of age. She left her husband and three children (now grown-up adults) to pursue higher education abroad. She has been teaching at Kawa University in Africa since her return. I interviewed Tamara in her office, because she lived a distance from the university; we both found it convenient to have the interviews in her office. Tamara and I were students at Kawa University during our undergraduate years. Although she was one year ahead of me, Tamara was able to pursue post-graduate education without a break, while I took a break after my first degree to start my family. Tamara was the first woman to become the deputy director of Student's Affairs at her university. I was impressed by the aura of excellence evident in Tamara's office. Tamara's office, unlike other offices in the newer campus buildings, was spacious. It was located in one of the oldest buildings representing the

legacy of the campus as a former British army barracks during the colonial period. Tamara's office used to be the barrack commander's office. Upon arrival at Tamara's office, I was received by the secretary and two office assistants. No sooner had I sat down than I was given a refreshing cup of tea. The secretary also informed me that Tamara was on the phone with the president of the university and that she would soon be ready for me. As I waited for my turn to see Tamara, I could not help noticing the beautiful window curtains that blended well with the color scheme of the office. The meticulously furnished office attested to Tamara's refined skills in interior design after many years of teaching college Home Economics. Before my eyes was the affirmation that domesticity, education, and administration must, surely, be compatible.

Tamara was the last respondent I interviewed. While I transcribed the tapes and the interview notes, I realized that I allowed Tamara a more extended period of time of uninterrupted self-narration than I did other respondents. Although I may have felt that I had probably asked my other respondents all the question I needed to asked, I noted in my reflective field-notes that at this point in time in my interview process I had learned to listen more.

Tamara's narrative mode was different from the other respondents. She narrated her life as a series of steps that connected with, and build on each other. Her narratives gave a sense of chronology and a broader outlook in terms of how domesticity and education were played out in her life. They revealed an interconnection of Tamara's past and present experiences and how these experiences helped to inform her future projections. The ability to see her life as interconnectedness of the past, the present and the future was what gave Tamara the sense of being in control of her life because she acknowledged every experience as an important aspect of her life.

In this chapter, I analyze Tamara's narratives about her experiences in the United States and after she returned home in Africa. I identify four thematic and analytical sections that constitute Tamara's story line. The first section, "In control of my life" is centered on Tamara's perception of being in control of her life. This theme weaves through Tamara's narratives. The second analytical section reveals how Tamara saw her opportunity to come to the United States as an empowering expe-

rience which enabled her to learn to speak her mind. I discuss Tamara's experiences of her life in academia in the third section, highlighting various challenges that she encountered. I conclude the chapter with a discussion of Tamara's vision about creating social and political spaces for herself and for other women through activism.

"IN CONTROL OF MY LIFE"

During my initial interviews with Tamara, I asked her how the education she had acquired changed her life and how she saw herself differently from other women who have not achieved as much. She said:

> In control of my life . . . I feel I am in control of my life. One thing that I have been able to do is identify myself. The ability to define one's self is one of the areas that most women in Africa are not able to do. To define yourself . . . to have your projections clear . . . to know what you want to do and where you want to go. I think I have my projections clear and this makes me feel that I am in control of my life. Whatever I want to do I make up my decision. My husband and children come after and only when they fit into my projections. And that is one of the things that most of us women are not able to do and that's why most of us do not move ahead.

Tamara attributed her sense of being in control of her life to the ability to define herself, have clear projections, and make decisions about her social and professional life. However, the realization did not come until much later on in her life. Tamara traced her life back to her first steps of the journey that helped chart her destiny and gave her the control over her life. She began by describing the role her parents played in encouraging her to go to school:

> My parents were a great inspiration for me and to my education. In my family we are three girls and a brother. In the 1950s and 1960s, people laughed at my father because of educating

101

girls. My father, a devout Christian, did not yield to such pressures. He has been a source of strength and a role model. He did not have a good education. My mother did not go to school but I call her an educated mother.

Later on in life Tamara joined a teacher-training program to train as an (S1)[2] secondary school teacher.

I did an S1 course—secondary school teacher and taught for many years. Later, I joined a degree program and soon after, I was recruited to go for further studies abroad. I got a government scholarship to go to the United States.

Tamara accomplished most of her academic endeavors as a married woman. She attributes her accomplishments to her husband's support stating:

My husband recognizes me as a partner and a spouse. He recognizes the importance of education. People asked him why he allowed his wife to go to school. I see a reflection of my father in my husband. When the opportunity came he was very supportive. The baby was six years old then and my husband agreed to take care of the children.

But even with a supportive husband, Tamara had to deal with societal and familial obstacles. She had problems with her parents-in-law and they blamed her for evading family responsibilities for the sake of education. However, despite her in-laws' resistance to her going to school, Tamara's life at this stage sounded normal. She did not portray signs of struggle because she seemed to have the support of both her husband and her father. Although it was unusual for her to have accomplished all her academic endeavors during her married life, there was no marked conflict of interest with her immediate family, compared to Tenji and Tausi.

However, there seemed to be a change in perspective when Tamara decided to go abroad. This period marked the beginning of yet another stage in her life when she started to speak out. Tamara observed that although she had left home to go to college before, this time it was different.

It was worse when I left to go abroad. Even my supportive father asked why I had to go back to school. . . . Will she ever come back? If I had listened to them I wouldn't have gone for higher studies.

Tamara traveled to the United States and was enrolled in one of the universities in the Midwest. Although she may not have known, then, the extent to which the opportunity and the experience of pursuing higher education in the United States would impact her life and her career, she was, nevertheless, excited to have had a chance to go abroad. Embedded in her narratives were her views about what being in control is all about, particularly, in reference to her experiences after coming to the United States. For example, she noted that "by the time you go through the bickering from the society and family you are very confident with yourself, you have learned to trust yourself and to act without fear." While many women would see themselves in control of their lives only when they can easily balance their multiple roles of being mothers, wives, and women, Tamara offered a different perspective from which to view the concept of "being in control"—the recognition of herself as an individual even as she enacted her other roles and identities as a mother and a wife. Being in control, therefore, denoted a political consciousness of who she was and what her rights were. But being in control also involved recognizing and challenging the socio-political structures of unequal gendered relations and positions that disadvantaged women.

I was curious about her experiences in the United States as I wondered, in retrospect, whether going to the U.S. was worth the trouble women had to face. In the following section I explore Tamara's sense of empowerment.

"EMPOWERED TO SPEAK MY MIND, TO SEE AND KNOW CLEARLY"

Mumbi: What were some of your experiences in the U. S?
Tamara: I have fond memories. The experience of travelling so far away.

That experience of being able to perform and discover your self. . . . There was a culture shock but that was dealt with [laughter]. (Tamara recalled that she got a "D" in her first assignment but she was quick to note that at graduation she had a GPA of 3.8). The exposure gives you confidence as a woman to say what you feel, do what you want. You know the situation of most African women . . . women here have to take a very low profile. There, I was empowered to speak my mind . . . to see and know clearly So empowerment was very important.

Tamara spoke of her sense of empowerment with nostalgia. She was aware that empowerment opened doors not only to her career, but also to her self-identity and outlook in life. She was very clear about the state of African women when she said, "because of these traditions and cultural constraints we have women who cannot speak when men are speaking and these are both educated and rural women." Identity and self-perception are crucial issues for African women because women are relegated to low status. As a result they feel helpless and in utter resignation to their fate.

Tamara's idea of empowerment was profound. Having been around educated women at the university, she was aware that even educated women were constrained by African traditions to speak their mind. This observation was echoed in Tausi and Tenji's narratives as well. Although most of the women Tamara was interacting with at the university had received a university education in their native countries, they were not, however, "empowered" to function fully as educated women within African cultural contexts. The society saw them as women, first, but not their education. This implied, therefore, that though education might be an important factor in African women's lives, it was not, in itself, enough to give women the empowerment they need. There was need for an epiphany, a life-transforming experience, to trigger one's self-consciousness. Tausi, Tenji, and Tamara described in their narratives, different transforming experiences that triggered their self-consciousness. While traveling to the United States provided Tamara the experience and the exposure that helped build her "confidence," Tenji experienced a unique moment in which she realized the "unrealness" of the family package. Tausi's stay in the United States provided a reflective moment

that enabled her to watch her life as a "movie."

In the edited book, *Women in Cross-Cultural Transitions*, Bystydzienski and Resnik give accounts of experiences of women from other cultures trying to make cultural transitions to the American way of life. Although most women in the book described the experiences of the transition into the new culture as disorienting and shocking, a few were appreciative of the fact that such exposure helped them "gain insights into the cultural differences, especially about family relationship and friendship"[3] While Tamara valued the exposure that coming to America provided, she was also aware that such an opportunity was not available to many women in Africa. She observed:

> What I know is that many women are oppressed. There are many women with lots of potential who cannot stand for themselves, who can't make a decision on what they want because they are afraid of societal expectations and [negative] comments.

The effects of gender inequalities on women's lives, perpetuated by the indigenous cultures and traditions have been the focus of many "Third World" feminists. In the book, *Dislocating Cultures: Identities, Traditions and Third World Feminism*, Narayan interrogates gender dynamics within cultural and familial contexts to expose factors that contribute to women's acceptance of cultural norms that are oppressive to them. Narayan argues that critical awareness of these gender or cultural dynamics neither translates into empowerment, nor propels women to take actions about their condition. In fact, most African women, educated and uneducated, are aware of the oppressive power of the African tradition, but they do not do much about it. According to Narayan:

> Women may be aware of such dynamics but may consider them to be personal problems to be dealt with personally without seeing them as systematic part of the ways in which their family, their culture and changing material and social conditions script gender roles and women's lives, or without feeling that they must contest them in more formal, public, and politi-

cal ways.[4]

Narayan argues that what women lack is "political connections" to other women through sharing their experiences in order to challenge the cultural traditions that oppress them. It follows, therefore, that in order to be empowered, it is imperative that African women understand and document their situation from their own points of view and based on their lived experiences. Through the political connections that Narayan advocates, African women's attitudes, perceptions and depth of their feelings about their common and shared issues would be revealed. The process of sharing would bring about "exposure," "confidence," and "empowerment" that Tamara is talking about. Narayan's idea of lack of political connections explains, therefore, why women succumb to, and are constrained by, cultural definitions that view them as inferior, regardless of their professional status or level of education.

However, Tamara underscores the importance of education for empowerment. Tamara acclaimed the good that comes from pursuing an education. She says, "I feel very good about it. . . my income. . . my family. I want other women to feel what I feel." Education in the present postcolonial Africa is the primary means to development of individuals. Because women are systematically denied equal access to education, they lack control of their lives because they do not control the means of production. Consequently, many women in Africa have not only settled for domesticity but also to a life of dependency. In reference to the status of the educated women in her institution, Tamara contended that although women were marginalized in many ways, education opened some doors that enabled women to occupy positions from which they can challenge the oppressive systems. Evidently, Tamara saw education as a springboard for critical thinking necessary for informing the process of empowerment. According to Tamara, education develops a form of awareness that:

> enables one to see, with humility, and gratitude, and pain, how much one has been shaped by one's contexts, to sense both the extent and the boundaries of one's vision, to see how circumstances can circumscribe as well as inspire, and to become self-aware to some extent of one's perspective of things.[5]

She further stated that education also illuminates choices available

to women but she was also aware that not all women are empowered to make those choices. Although Tamara saw education as necessary for empowerment, she also pointed out that empowerment is strongly hinged on "being bold enough and trusting [oneself] to make rational decisions." As Tamara narrated her experiences as an administrator in academia, she focused on her sense of being empowered to make rational decisions. However, she was also aware that the reality of the administrative structure at the university hindered such empowerment. In the next section, I articulate Tamara's experience of the tension between being empowered and disempowered.

LIFE IN ACADEMIA

Tamara was one of the few women who have attained high academic standing in her university having served as a faculty member at Kawa university for over twenty years. I asked her about how she envisions her life in academia.

Tamara: It is very difficult. Even as I am here, I have to produce because if I don't deliver, the society is fast enough to blame me as a woman than a man. Also we have to know that men are not happy when we are sitting in these positions. I am the acting director for Students' Affairs at this university. This position works closely with the dean of students. It coordinates all other departments as far as students' needs are concerned. I am the link between administration and students' residence office.

Mumbi: How about promotion?

Tamara: I have advanced steadily and I compete very well with the men. If you qualify on the laid down criteria, you get your promotion. I must say this university is a bit slow in awarding promotions. I am waiting for my promotion to the position of associate professor. It has taken long but it is not because I don't qualify but systems just take time.

Mumbi: Is this the case with other women?

Tamara: I feel that though women have many problems

compared to men—multiple responsibilities, I believe those who work hard get what they merit. A few women professors have been awarded positions but the ratio is still minimal—about five in the whole university.

Mumbi: Why do you think this is so?

Tamara: As women, we have multiple roles that limit our progress as fast as men and these roles are never considered. This works against us quite a bit and we have a long way to go to catch up with men who are very many in professorial positions.

If I did not have an idea of what it was like to teach in a university in Africa, I would not have understood why Tamara was giving a contradictory message. She talked about empowerment, the need for education and being in control of her life. Yet she portrayed vulnerability as a woman when she said "men are not happy when we are sitting in these positions." Although Tamara was qualified, and had an added advantage for having trained abroad, she considered that she had not been adequately promoted. She observed that even after having worked for the university for twenty years, she had not been promoted to the position of an associate professor yet, but she said, "if you qualified on the laid down procedures, you get your promotion . . . but it is not because I don't qualify but systems just take time." I could see Tamara struggling to put these sentiments across because as much as she felt she had not been rewarded, she was uncomfortable showing the dissatisfaction openly. Tamara's contradictory articulation of her lack of promotion was evident when she said that the promotion has taken long "not because I do not qualify, but systems just take time." However, in the same vein, she said that "women have multiple roles that limit our progress as fast as men." If the assumption was that women are not able to function as effectively as men because of the weight of the domestic responsibilities, then Tamara's argument that her promotion had taken long because the systems "just take time" did not hold. Tamara's narrative description of patriarchal systems at her universities is similar to those described by Tenji. In both cases, there was evidence of relationship between the society's gendered perception of the women's professional ability and the rate at which they were promoted

irrespective of whether or not they were qualified. Consequently, promotions were not entirely dependent on qualifications, as Tamara would have us believe. Unlike Tenji, Tamara was very careful not to paint a negative picture of her university despite her claim that she had been empowered to speak. Having eventually risen to the position of an administrator, she was rather hesitant to openly criticize the system for the delay in her promotion. Tamara's disposition bothered me. Is Tamara showing a different type of conformity? Belonging and yet not belonging to the patriarchal university system? Is this a healthy situation to be in for educated women such as Tenji and Tamara to whom women of African look for help and direction?

Empowerment was another tension evident in Tamara's narratives. Although Tamara felt empowered, the extent to which she was empowered is dependent on the social circles within which she operated within the university. She sometimes found herself not adequately empowered to break through some barriers of patriarchy.[6] Tamara's contention that "we have a long way to go" attests to the uphill battle women have to fight to fit in the society that still defines them in relation to domesticity. And because the number of women in her position is small, their voice is silenced even as it is privileged in other circles.

As Tamara pointed out, women find themselves working extra hard to get accepted as diligent workers and leaders. Trying to fit into the different worlds of the home and profession has been a struggle for many African women. For Tamara, trying to fit into different administrative roles at the university necessitated her to inhabit different subjective positions, which were in constant flux. As her subject live positions changed within the academic circles and between the center and the margin of her administrative arena, so did her empowerment. That is, there were times when she felt empowered and times she felt disempowered as she moved back and forth from oblivion to prominence. For example, she may have felt empowered as the director of Students' Affairs but felt disempowered as a member of the voiceless female faculty. We saw Tenji struggling with the similar ambivalence of sometimes acting empowered and other times disempowered. Tamara's positioning herself in this dynamism is important because it shows her realization that empowerment is not a one-time thing. Empowerment is not guaranteed for women and, therefore, it must

be consciously and consistently pursued.

Although this might sound contradictory to Tamara's earlier statement of "being in control of her life," it became clear that empowerment required a continued ability to negotiate her positions. Further, although Tamara talked of being in control of her life, it is evident that she was not always in full control of some areas of her life. I argue therefore, that for women to have empowerment it must infiltrate every aspect of their everyday lives as they constantly make decisions that are important to them as women. Consequently, Tamara was aware that as much as she might be empowered, she, at the same time, needed to be more empowered. Talking about how, as a woman administrator, she had to continually prove herself, Tamara said "we as women have to perform . . . stand by what we believe and show men that we can perform as well or even better than them." Consequently, Tamara saw in her empowered position an opportunity to look for ways to create spaces for a collective struggle for herself and other women.

"CREATING SPACES FOR MYSELF AND OTHER WOMEN"

Tamara's story is significant in portraying the dimensions of women's struggles for autonomy within a hostile male environment. It is depressing to see the same kind of hostility Tenji was dealing with replicated in Tamara's situation. In order to identify and amplify gender dynamics that constrain women's control of their destiny, I asked Tamara what she thought women in Africa need to do to improve their status based on her long experience in working within the university.

Mumbi: What are your views about the future of African women?

Tamara: We have to stand up for ourselves. We have to create spaces for ourselves and other women. Some women, even those who are educated are discouraged simply because they do not want people to speak about them. They have yielded to stay in those low positions in the family just to protect their name . . . so as women we have to perform . . . show them

that we are worth something . . . make our views known right from home and in whatever dimension. Show the men that we can perform as well or even better than they can. So it is a situation where women individually and collectively have to work hard to advance their lot.

Tamara's contention of collective and individual efforts of African women to advance their lot is important for strategizing the future of women in Africa. The journey toward emancipation of African women is not a one-woman journey. It requires collective efforts. This theme was reflected in this study and resonated with the need for women to "gain" themselves. In her position as a director of Students' Affairs, Tamara had an extensive interaction with women in higher education and showed a profound belief in the value and potential of African women. However, she was also deeply concerned about the complexity of the ideology of domesticity and the extent to which such an ideology works to limit women's attempt to change their social destiny.

The collective and individual efforts will sensitize women not only about the need to address their status but also to see their status as a product of the wider society. The women in this study seem to be struggling individually within their own private and personal lives. Although personal lives must be seen as the starting points for social change, the connection must be made explicit between women's subordination, the political structures, and the ideologies that inform our values for a meaningful social change to occur. Understanding this connection is important because women will see the need to go beyond changes at the level of their personal lives and demand a form of societal change. African women will have to initiate this change by deliberately and consciously confronting those structures that hinder the development of their potential at personal and societal levels. As Tamara suggested, "standing up for themselves" was only possible when they realized the importance of self-awareness and the tragic consequences of lack of it. I argue that though culture or society assigns identity, it is important to realize that the power to name and challenge the ideologies that shape such identity lies with the individual women themselves.

Further, depending on the individual circumstances, the power to name and challenge these dominant structures is either dormant/invis-

111

ible/unrecognized or, vibrant/recognized and utilized, to advance the new notions of who we are as women and or individuals. Ultimately, the ability to recognize and use this power to transcend boundaries of identity is the most liberating thing that can happen to African women educated or not.

In articulating African women's need for an empowered social destiny as a shared responsibility, Tamara and other women I interviewed identified "moving away," the "separation," and the "diasporic experience," as a crucial source of empowerment. And because not all women will have a chance to move away, Tamara felt that as an educated and empowered woman she has an obligation to mobilize other women in creating political spaces for them through local activism. She saw agency or "the passion to want to see change in the lives of African women" through activism as an important component of empowerment. This realization is as personal as is it is collective.

As we neared the end of the interviews Tamara spoke about the various ways she felt she was helping creating spaces for women.

> I have made a commitment to make an impact . . . I think we have a chance, a very good chance if we admit that all of us have a role to play, a duty to perform. I sit on many school boards. I am able to talk about and express my sincere views about the education of girls. I am currently consulting for an organization that deals with gender and development. I attend international forums on women's issues and I publish a lot. International exposure has enabled me to give a broader perspective to African women's problem and ways of dealing with them.

Talking to Tamara was very enlightening. I was able to see in her a profound sense of commitment and the ability to use what she has—a good education, position, courage, and determination to help advance women's cause in Africa. Most importantly, talking to Tamara brought to my attention the complexity of the environment within which educated women in Africa must operate. The major obstacle that educated women have to reckon with is the patriarchal institutional structures. Tamara's life in academia epitomized another tension between the institutional structure and the individual. While I saw Tamara's enthusiasm to make a difference within the universi-

ty, I also saw her restrained by the institutional structures that were difficult for a woman to penetrate. As a result, women are constrained in terms of how much they can do to make an impact for themselves and others within the university environment. While it was depressing to see how women were made to contend with a hostile environment, it was also encouraging to see how they circumvented the structures, striving to make a difference outside these structures by using their talents as individuals. By talking to Tamara, I was able to see how she refused to be held back, but instead striven to make a difference as an individual outside of her job. Out of the realization of how difficult it is to change these institutional structures, she has opted for other ways that are less threatening but equally effective in the long run. Tamara takes advantage of her education and her experience to make an impact in society by getting involved in school committees, gender development forums, and consulting services on issues related to women's education. Talking to Tamara was both a challenge and a source of encouragement. At the end of the interview sessions we both felt bound together by our passion to change for the better, in whatever way, the destiny of African women. As Pala rightly says, "a concerted effort has to be made to bring about genuine change. The world [can] play a part in helping the process, but African women themselves have to take the lead in carving their destiny."[7]

Notes

[1] Brunner, 1993, p. 6.

[2] This is a teacher-training program that prepared secondary-school teachers who did not meet the requirements to enroll in a degree program at the university. After training, the teachers were certified as Secondary 1 (S1) teachers.

[3] Bystydzienski and Resnik, *Women in Cross-Cultural Transitions*, 1995, p. 25.

[4] Narayan, *Dislocating Cultures: Identities, Traditions and Third-World Feminism*, 1997, p. 11.

[5] Narayan, 1997, p. 3.

[6] Kiuva-Ndunda, 2001.

[7] Pala, 1995, p. 46.

Chapter Six

REFLECTIONS ON FEMINIST METHODOLOGY

> Our knowledge is always marked by gaps, slippage, unde-
> cidabilities perhaps never noted before when we clung so hard
> to presences, essences, fixities.[1]

In this chapter I critically reflect on how I, as an African feminist scholar, think about feminist methodology. My interest in looking close-ly at the feminist methodology as a process emanated from my own ten-sions and ambiguities as an African feminist scholar using a Western fem-inist perspective to guide the research on African women. Feminist methodology, in its ideal sense is "inclusive" in that it acknowledges the biases of the researcher, the everyday experiences of women and the var-ious unique contexts within which they live. Additionally, feminist methodology takes seriously the stories women tell as sources of data as well as the basis for knowledge construction.[2] Because of its sensitivity to the subordination of women, feminist methodology becomes, therefore, the appropriate vehicle through which to facilitate a realistic study of women' experiences.

Although Western feminism has shown considerable commit-ment to accommodating women from other cultures, notably since the onset of third-wave feminism in the 1990s, feminist research and scholar-

ship is still predominantly dominated by Western feminist conceptual frameworks.[3] Reviewing extensive feminist literature not only helped me to see this shortfall, but also led me to look at what the Third World feminists were saying about scholarship on African women in Africa and the Diaspora. Based on this literature I reflected on the tensions that I struggled with as I conducted this research.

As feminist scholars and authors, my professors taught and trained me to see women's issues through the eyes of feminism. Feminism has not only influenced me to be aware of the social dynamics and power relations in the world around me but also to look critically at my own life and self as an individual. I was not only able to use the feminist concepts and principles to critique my own life but I also used those concepts as warrants to support the appropriateness of engaging various aspects of feminist methodology in studying African women. Therefore, I presented the discussion on feminist methodology and life-history narratives fairly unproblematically and in truth, they sufficed. However, as I continued reading and learning about African feminism and other global feminisms, which were also important to my work on African women, I became increasingly aware that there was no universal form of feminism, but rather many feminisms.[4] Because of the cultural, historical, and social differences between the experiences of women in Africa and the West, it became apparent to me as I continued with the research that I needed to further explore possible gaps in my work as a result of relying so heavily of Western feminism. In this chapter, I problematize Western feminism and explore gaps where contextualized understandings of African women's experiences must be included. I return to the question of methodology in this chapter because it also became increasingly clear to me that I could make a contribution to feminist methodological literature by looking into alternative ways of doing more contextualized research based on culturally specific everyday experiences of African women. As a culmination of lessons learned through my reflections on the process and the practice of doing feminist research, this chapter also functions as my methodological conclusion.

In this reflective section, I focus on one major overriding question: How do I use Western feminist concepts and theories that reflect a

Western social and contextual perspective, to study and interpret African women's experiences? I identify two areas that I struggled with in my study: 1) the exclusiveness of feminist concepts and 2) the ethnocentric assumptions about shared experiences. I not only highlight the challenges of doing feminist research on African women using a Western feminist perspective, but also raise issues that can suggest future direction for feminist research on African women.

Exclusiveness of Feminist Concepts

Tensions in Western feminist thinking alludes to the relevance of the concepts and their application to, and implications for African women. First, Western feminist theory, research and epistemology are still invariably about Western women. The Westernized category, "woman," further works to obscure heterogeneity and cuts off any examination of the significance of such heterogeneity in informing feminist theory. Using the category, "woman," as a concept defined within the Western perspective to understand African women becomes problematic because it does not necessarily reflect the reality of African women. In this study, I tried to reconceptualize the category, "woman," in order to fit the attributes of African women. However, I realized, that the Western feminist conceptual schema about what a woman is or should needed to be more inclusive in order to help analyze African women's experiences. Mohanty rightly observed that:

> Assumptions of privilege and ethnocentric universality on the one hand, and inadequate self-consciousness about the effects of Western scholarship on the third world in the context of world system dominated by the West on the other, characterize a sizeable extent of Western feminist work on women in the third world.[5]

Therefore, although the category "woman" is an important concept of analysis, its application to the African women's lives in the form in which it is defined and understood within the Western feminist perspective is problematic because the context for African women is different. One cannot, for example, talk of category African "woman" as a normative context. Attributes like poor, wealthy, rural, urban, uneducated, educated, which are

markers of the category "African woman," are dependent on differentiated contexts within which African women function. The danger in using Western concepts based on a generalized definition of the category "woman," as White, middle-class, educated woman to study African women is that African women do not neatly fit into these categories. If these concepts remain rigid and exclusive, then they misrepresent African women's lived reality. The category "woman," as both an analytical and political concept must have the ability to expand to include all markers, and to encompass the specificity of subject positions and locationality of African women. The concept of a category "woman" that does not encompass these attributes becomes limited in its relevance to African women's interpretation of their reality. For example, how do I explain Tenji's situation when she uses her "essence" as a woman (based on the Western concept of category woman as a basis for fighting for equality) to demand to be selfish for the first time, then gives up this essence in order to function within the African patriarchal-sexist university environment? How do I explain that as Tenji embraces the Western feminist expectation of fighting for her equality she also questions it because her fights in life are not limited to only equality, but various other forms of oppression including colonialism, patriarchy, and sexism within African traditions and postcolonial demands? How do I explain that by accepting the Western definition of category woman, Tenji will be risking being re-colonized by the precepts of Western feminism?

The Westernized concept of motherhood was yet another indication of nuanced interpretation when studying African women. Thus, trying to express how educated African women experienced, understood, and defined motherhood using the essentialized Western notion of motherhood became problematic. In her article, "Family Bonds/Conceptual Binds: African Notes on Feminist Epistemology," Oyewum observes that in defining African women "feminist anthropologists of Africa tend to focus on . . . [woman as] equivalent to wife in the West."[6] The Western concept of motherhood generally implies women staying home with the children or choosing not to work outside of the home because there is a secure provision from the male head of household. In contrast, motherhood in an African context has involved ensuring that children have food and other provisions regardless of the mother's physical presence in the home. In this context, therefore, a mother who left her children to the care

of a neighbor or extended family to go to work and provide for her children was also considered a good mother.

Oyewum also draws the attention to the different meanings of the concept of "woman." She observes that while "in much feminist anthropological research, *woman* is used as a synonym for *wife* . . . wifehood in many African societies has traditionally been . . . seen as a transitional phase on the road to motherhood" rather than a form of identity.[7] In articulating cultural differences, Oyewum shows how women in Africa are viewed in relation to their children, thus making motherhood a preferred mode of self-identity for women in Africa compared to wifehood in the West. What makes mothering in Africa distinct is the fact that motherhood is very contextual with very contexualized meanings and practices. In line with the foregoing, essentializing motherhood and purporting it to have the same meaning, therefore, masks the intricate contrasts in how African women enact and make sense of motherhood and mothering. In addition, trying to explain the intricacies of African motherhood using the Western conceptual perspective of *wifehood* not only distorts but fails to reflect the plurality and reality of African women. The women in this study struggled to redefine themselves anew because of the attributes that characterized the Western meaning of motherhood. Compounded also by the African tradition, the colonial legacy and the post-colonial discourses on motherhood, their reality was also not adequately reflected. I had to do a lot of explaining in the interpretations in order to convey the meaning of the concept of motherhood as understood by the African women respondents within their varied contexts and subject positions. Redefining themselves as mothers away from home emerged as an important concept to explore maternal experience from the standpoint of women who define themselves as mothers but whom, because of their prolonged separation from their families may not be viewed as good mothers by the African society. The women in the study recognized the important role played by education in defining good mothering because it promised better chances of providing for their families despite the separation. However, while the African society, in its perception of domesticity, condones mothers who go out to work to provide for their children, it seems to exclude education as a reason to acknowledge distant mothering. Distant mothering seems, therefore, only acceptable when it functions within culturally regulated

geographical boundaries. This emerging identity as absent mothers/mothering resonates with the current growing scholarship on "transnational mothering."[8] In her study on mothering from a distance, Parrenas observes that the practice of transnational mothering, resulting from an increasing number of immigrant mothers who are taking advantage of the labor opportunities abroad can no longer be ignored as an important catalyst of the need to redefine motherhood. Transnational motherhood promises to not only rupture the gender ideologies of mothering, but also the traditional division of labor that puts the men and women in charge of production and reproduction respectively. Drawing a parallel with the experiences of the women in the study, it is imperative to look at their experiences of motherhood within the intersection of domesticity, education, and distant or transnational mothering in order to reflect the reality of their diasporic mothering experiences. I remember when I first came to the United States, I dealt with a lot of questions from my colleagues who were trying to understand how I was able to deal with being away from my family for extended period of time and still see myself as a good mother. It follows, therefore, that understanding motherhood from the perspective of the African women requires an interpretive conceptual framework that illuminates not only the social, historical, and cultural perspectives but also, the specific personal and individual contexts.

Assumptions about Shared Experiences

Collins[9] describes black feminist thought as situated knowledge embedded in communities where African women live and work. She sees women's subjective experiences as a form of knowledge situated and generated from an individual's own experiences, the social locations as well as the interactive engagements of everyday life. While the context within which White Western women function may be specific to class and gender, the assumption is that this context is universal. However, as this study showed, African women function within class, gender, tribal, ethnic, and national locations. Their experiences are compounded, further, by African culture, African patriarchy, imperialism, colonialism, and post-colonial forces. The complexity of contexts in which the African women in this study exist effected not only their identities but also the decisions they made about education. In addition, the concept of dislocation from their

countries (or diasporic experience) is also a major contextual factor. This complex multiplicity of contexts requires a methodological approach that is especially sensitive to these issues. In trying to understand the African women's decision to further their education abroad, it is important to consider these specific situations in order to appreciate their courage. In addition, these contextual locations need to be theorized if the multi-layered subjectivities of African women are to be addressed as important and accounted for in the process of feminist knowledge construction.[10]

As a feminist, my initial concern was to engage feminist methodology in order to help understand and document African women's experiences related to the complex situations of pursuing higher education. However, as I tried to portray this complexity throughout this study, I felt restricted because the concepts and contexts on which my interpretations were based did not provide the latitude I needed. How, then, do I explain or portray the complexity of African women's lives and the meaning they give to their experiences without having to break the Western feminist conceptual boundaries? How do I authenticate my interpretations if, and when, the conceptual theoretical framework does not allow me the flexibility to do so? Because the concepts from the Western feminist perspective became the points of reference in the process of my interpretation of African women's narratives, I found myself always explaining why the experiences of African women were different from the Western women. As Brown rightly puts it:

> While any feminist theory should reflect all forms of human diversity, this standard has rarely been met. . . . They have tended to develop theories by and about women of European heritage and they *simply comment* in passing that what they have said *probably applies* to peoples from other oppressed groups as well.[11] (emphasis mine)

In their writings, Third World feminist scholars[12] have echoed the same frustrations. Third World feminist scholars find themselves always trying to bridge the gap between their own social experiences and the available theoretical framework developed from the perspectives of Western feminists whose experiences fit much more comfortably into the familiar conceptual schemes. Similar sentiments are expressed by Lugones thus:

When I do not see plurality stressed in the very structures of a theory, I know that I will have to do a lot of acrobatics . . . to have this theory speak to me without allowing the theory to distort me.[13]

These scholars suggest a theoretical approach capable of acknowledging the multiple contradictions and complex subject-positions African women occupy within cultural and economic locations.[14] I, therefore, argue that in the process of studying the lives of African women, it is inevitable to confront the problematic issues of identity, invisibility, powerlessness, representation, and other images embedded in Western feminist discourses about African women. For African women and others who live in multiple worlds with multiple identities, differences and multiplicity compose the context of, not only their understanding of what it means to be African women but also, how they experience their lives. Therefore, feminist theory, research and methodology must validate this context.

Clearly, there are tensions in researching African women using Western feminist perspectives. Whereas I have focused on just a few of them, I felt frustrated that I did not have answers to most of the questions I raised. The process of reflecting on these issues was mentally, intellectually, and emotionally demanding for me as a researcher, a feminist scholar, and as a feminist activist committed to seeing changes in the lives of African women through meaningful research. However, I argue that such tensions do not always only constrain; they also enable. They must not serve as barriers to action, but as preconditions for necessitating rethinking the future direction of feminist research and scholarship on African women.

Many of the issues that I have raised here and with which I struggled in studying African women have been echoed by other feminist scholars in Africa and the Diaspora. Many feminist scholars have called for shift in paradigm in order to reexamine and reconceptualize traditional strategies and institutional contexts of research and scholarship on African women.[15] In calling for more theoretical work on African women as a basis for informing scholarship on African women wrote, Mama wrote:

A major objective for such work must be to develop appropriate conceptual tools as well as grounded theory . . . in experi-

ences and realities of the specific Black women concerned and which incorporates the contingency of action of experiences.[16]

Mama argues that it is vital to work within a framework which is able to recognize, for example, gender and class issues as interacting with ethnicity—a factor that is not provided by a theory of a unitary female subject. To do this, there is need to institute new strategies that support new knowledge and truths independent of the "givens" of Western feminism. Such new knowledge and truths must emphasize more the relationship between theory and practice and the specificity of the sites in which they might be developed.

While arguments put across by Mama are important, I wonder whether in calling for any form of theoretical "framework" for Black feminist epistemology does not, in actual fact, reproduce the very thing Mama is objecting to. I argue that a framework denotes boundaries of exclusion and inclusion and, therefore, it is still problematic as a basis for research for African women's social change. Therefore, to comprehensively address the issues and tensions that I have raised here, there must be specific identification of what needs to be changed. I contend that what needs to be addressed is the exclusiveness of Western feminist methodological frameworks that restrict and contain feminist research processes. Building on Mama's call for a different form of theoretical framework and at the same time problematizing her idea of a framework, I am suggesting and theorizing a "frameless-framework"—a system of feminist knowledge production that is characterized by "fluidity" of dimensions and strategies to reflect and capture cultural diversity and subjectivities in the lives of African women.

THE FRAMELESS-FRAMEWORK

The "frameless-framework" that I propose puts at the center African women's experiences while, at the same time, recognizing that these experiences are mediated by the various social forms that include, politics, traditions/cultures, private/public social spheres, access to education, and differentiated locationalities. Centrality of African women's experiences is important in any research on and by African women for

various reasons. First, it creates and claims a rightful space for the women in the process of creating knowledge. In theorizing the relation between space, knowledge and power, Foucault posits that "space is fundamental in any form of communal life; space is fundamental in any exercise of power."[17] Secondly, spatializing African women ensures that they do not exist as an appendage (or addendum) to other systems of knowledge construction. Rather, they are an integral part of the interconnection between systems of knowledge production. Third, the centrality of African women's experiences is paramount not only to understanding themselves and the world around them.

I envision the *framework* that is *frameless* as capable of being both stable as well as mutable. In my theorizing about the frameless-framework, I draw from Gleick's work on chaos theory that describes human actions as a complex system with "points of stability mixed with instability, and regions with changeable boundaries."[18] Using the analogy of a trellis to explain the notion of the *frameless-framework*, I show that a trellis has a framework (or structure) but is frameless. Because *framelessness* (or absence of a defining line that encloses the trellis) blurs and disrupts the potential enclosing lines of the frame the structure of the trellis itself is open for possible extensions if need be, depending on the type and growth of the desired plant. The points where the cris-crossing planks of the trellis meet are the stable points that hold the framework together. Concepts like gender, locationality, subjectivity, motherhood, domesticity, and empowerment are the stable points (or moments) of the structure that the *frameless-framework* engages to guide research on women's experiences. Although these stable points are fixed they are, however, loose enough to allow for the structure to change shape according to the nature or the focus of study or phenomenon under observation. Thus, although the *frameless-framework* has its moments of stability, the dynamism of these stable moments and the framelessness of the framework makes it is "inherently open-ended . . . susceptible to modification and explosion."[19]

Framelessness also blurs and disrupts the defining lines of the frame, making the framework fluid and flexible to possibilities of exploring new grounds for developing conceptually relevant and contextually specific methods of researching African women.[20] For example, by taking the feminist concept of empowerment as one of the stable points in the

trellis, the *frameless-framework* enables one to extend this concept to a specific social, cultural or tribal context of an African woman. Thus, allowing understanding of how empowerment is understood and interpreted within that specific context. In advocating for a *frameless-framework*, I argue that it is in those moments of instability and fluidity that the identity, uniqueness and separateness of issues concerning African women are not only illuminated and understood, but also appreciated within feminist discourses.

I also envision the *frameless-framework* as capable of operating at various levels of knowledge construction. At one level, the *frameless-framework* positions African women as authentic insiders who must be involved in the knowledge construction about themselves within the specificity of their contextual experiences. At the next level, the *frameless-framework* brings together multiple contradictions and complex subject positions that women in Africa occupy and specificity of their locationality to create a site within which theories about women's lives are developed. Informed by critical post-colonial and postmodern epistemological paradigms, the "frameless-framework" provides the context within which African women's experiences of their everyday lives are interpreted and understood. Interpreting African women from these contexts allows for grounded theories and knowledge about women to emerge and be developed. Grounded theories developed within conceptually relevant and contextually specific meanings will eschew assumptions about the universality of the feminist concept (like motherhood) as well as the belief about the relevance and applicability of Western women's issues, problems and perspectives to African women.[21]

The *frameless-framework* is also "projective" and "evolving." It is projective in its ability to fit into changing environments, and evolving in its ability to change form. In addition, the *frameless-framework* allows for interactive and discursive processes. The discursive and interactive processes, consequently, function to illuminate deeper meanings of women's experiences in relation to the various social, cultural and political contexts and locationalities. Therefore the *frameless-framework* can be used to study women from other cultures as well. I see the strength and sustainability of the frameless-framework in its paradoxical discourse of stableness and fluidity. Placed within this *frameless-framework*, feminist

methodology is not only allowed to fully operate in its entirety, but resolves some of the tensions between Western and African feminist scholarship and discourses. Because the *frameless-framework* allows for these discourses to be in tension as they are in agreement, to be different as they are complimentary, to be stable as they are in constant motion, to be clashing and fragmenting as they are unifying, new knowledge is constantly being created and shared in a more egalitarian manner. Most importantly, because these discursive discourses are in dialogue, they are more open to accommodating ideas from each other. The paradoxical discourse of the *frameless-framework*, therefore, evokes creative responses to these tensions. It demands also that we constantly and consciously become aware of, and accept ourselves and the contradictions we embody as women and as feminists. This conscious realization allows for development of new sources of theories of living, relating and constructing knowledge about ourselves and about others.

I conclude, ultimately, that feminist thought/theorizing based on the frameless-framework is liberating in its vitality, in its refusal to stop changing, and to stop growing. Such a theory is also necessary for informing feminist scholarship in which women's representation reflects their own version of who they really are. This also allows women to embrace feminism because it is personal and not bound by another's negative interpretation of their reality. The commitment to this effort must truly be the core of every feminist project. This dire need to develop alternative framework for researching African women resonates with Audre Lorde's words:

> "*For the master's tools will never dismantle the master's house.*"[22]
>
> —Audre Lorde, 1984

Notes

[1] Greene, 1992.

[2] Bloom, 1998.

[3] Bulbeck, 1998; Mama, 1995; Mohanty, 1991; Terborg-Penn, et al, 1996; Okeke, 1996, 1997.

[4] Aina, 1998; Bulbeck, 1998; Oyewum, 2000; Tripp, 2000.

[5] Mohanty 1991, p. 53.

[6] Oyewum, "Family Bonds/Conceptual Binds: African Notes on Feminist Epistemology, p. 1096.

[7] Oyewum, p. 1094.

[8] Parrenas 2001, p. 361.

[9] Collins, 1998.

[10] Okeke, 1996; Narayan, 1997.

[11] Brown, as cited in Goldberger et al., 1996, p. 197.

[12] Mama, 1995; Collins, 1998; Narayan, 1997; Mohanty, 1991; Terbog-Penn, 1995; Okeke, 1996.

[13] Lugones as cited in Spelman, 1988, p. 80.

[14] Giroux, 1992.

[15] Mama, 1995; Mohanty, 1991; Terborg-Penn, 1995.

[16] Mama, p. xii.

[17] Foucault, 1977, 984, p. 252.

[18] Gleick, 1988, p. 299.

[19] Kushner, 2000, p. 44.

[20] Mama, 1995; Terborg-Penn, 1995.

[21] Kelly and Elliot, 1982.

Chapter Seven

CONCLUSION

I began this book by asserting that while education is not readily available to many women in Africa, those who choose to further their education outside of their country suffer alienation and exclusion from the society. African women continue to grapple with traditional, economic and political structures that inhibit their pursuit for education. In this book, I argued that domesticity and education are two major oppositional concepts and ideologies that created tensions which negatively impact African women's access to education. Tensions between education and domesticity emanate from the conflicted values within the social, historical, and political contexts of African culture and traditions, the colonial, and the contemporary post-colonial Africa. Embedded in these different contexts are conflicted discourses on the role and identity of African women.

I began also with the assertion that this book puts at the center the narrative experiences of three African women pursuing higher education in order to illuminate not only the struggles they faced but also how they dealt with issues of pain, losses, and ambivalence in their pursuit of higher education abroad. Through narratives of their experiences, I hoped to reveal how social systems and institutions perpetuate gender inequalities

and stereotypes that work to marginalize women, thus inhibiting the development of their full potential as individuals and as citizens.

In addition, I began this book by affirming my commitment to feminist perspective in researching African women. Feminist perspective has viewed research as a "praxis" emphasizing the process of joining theory and practice or theory and action which is based on the political and ideological commitment towards changing the position of women and, therefore, changing the society. What makes a research feminist is its commitment to feminist ideals premised on the fact that reality and knowledge are socially constructed and that social institutions and attitudes are often the basis for women's subordinated positions in society. Feminist research is also characterized by its emphasis on women's lived experiences as a basis for knowledge construction through the stories they tell and the meaning they give to their experiences.

In this book I have looked at the narrative experiences of Tausi, Tenji, and Tamara. These three women, from different countries of Africa, saw themselves as unique for having defied their homeland traditions that limited the role of women to domesticity. In trying to weave together the two oppositional areas of domesticity and education, the women's narratives revealed anger, helplessness, and defiance, as they grappled with personal and social tensions raised by the efforts to attain education. The problem of domesticity was not only a problem effecting choices the women made, but it was also a problem related to inequality between men and women as it reflected gender biases that determined who had access to higher education and who did not. Domesticity and education was also an identity problem played out in gender stereotypes that defined women's identity in relation to the home, thereby, making problematic the identity of those women who chose to pursue an education. At this juncture, the crucial question is: Where does this account of experiences of African women pursuing further education abroad take us with regard to understanding and addressing the problem of domesticity and education for women in Africa? In this book I did not only bring to the fore the complexities of this pernicious problem. I also situated women's conflicted subjective lived experiences within the dynamics of social context in order to substantively show that the status of women and women's education in Africa is a social problem requiring social solutions.

My position as researcher and a member of a select group of women from Africa pursuing higher education abroad allowed me to interact and relate with the women much more intimately. The stories they told, therefore, were not monologues, but rather a product of our interactions and sharing pains, fears and losses. Out of this relationship developed the passion, commitment and empathy that motivated me to turn this study into a locus of activism. First, I view this book as a forum from which women's stories about their experience are amplified, documented and, therefore, given a voice. Secondly, I viewed this study as a mouthpiece for my activism through which I desired to see positive changes for women and women's education in Africa.

Out of the insights from the interpretation of these women's stories came the need not only to do something about the problem of domesticity and education, but to give it the urgency it required. My activism is, therefore, targeted to three important groups of people. I believe I have something to say: 1) to the African heads of states because the issues discussed here have social, political, legal, and policy implications for women; 2) to the vice-chancellors (presidents) of universities in Africa where, unfortunately, the patriarchal structures, attitudes and values that constrain women are still condoned and promoted by male colleagues; and 3) finally to the younger generation of African women who must be cognizant of the issues raised through the experiences of these women, who as role models, have dared all to gain themselves through higher education.

I, therefore, write a letter to each of the groups mentioned above, as a form of my activism on behalf of myself and the women of Africa. For "[I] will no longer bear to watch silently from behind the camera. [I] will not document tragedy as an innocent bystander."[1]

Note

[1]Behar, 1996, p. 1.

Appendix

LETTERS TO THE GOVERNMENT

The Heads of Governments in Africa
African Heads of State Summit
Organization of African Unity

May 10, 2001.

A letter to you on behalf of African women pursuing higher education abroad

I speak to you today on behalf of the African women who are pursuing and have pursued higher education abroad. As a result of the study that I conducted focusing on the experiences of these women and having had similar experience myself, I can speak confidently, on behalf of this group of women.

The study that I conducted focused primarily on the stories the women narrated about their experiences of leaving their families in Africa to come to the U.S. to further their education. They saw education as important for their personal and professional development as well as for improvement of the welfare of their families. However, their views about self-improvement through higher education were conflated with the pain and the losses they experienced by being away from their families. They

discussed their emotional and psychological ambivalence as they tried to redefine themselves. Their narratives also revealed how society, through its various social systems and institutions, perpetuate gender inequalities and stereotypes that inhibit African women's access and pursuit of higher education. One of the most entrenched stereotypes in African women's lives is that the African woman must be domestic. This stereotype has been used, among others, to place the African woman in her assumed "natural" location within the domestic sphere. The purpose of this letter is to sensitize you, as heads of state, to the plight of African women who choose to study abroad.

This letter is based on two fundamental premises. First, the plight of educated African women is never given enough attention. While considerable research has been done on women in Africa, very little attention has been given to educated women because the "African woman" as an object of study has been defined by researchers as "poor and uneducated." Further, because women who choose to study abroad are viewed as privileged, their marginality is often invisible. Very little research has focused on women's stories to find out how women feel about the issues that matter to them. Their experiences and voices have been ignored. For example, although women experience separation from their families differently from men, there is very little interest for researching vital issues like the tension between education and domesticity and the extent to which such tension inhibits and effects the choices women make about education. The second fundamental premise is that, while traditional beliefs, values and attitudes about women and domesticity no longer reflect the reality of women today, government policies and regulations on women's issues are predicated upon these same values. As a result, the policy makers who are mainly men trivialize women's problems.

In the light of the above, therefore, understanding the concept of domesticity is important in order to comprehend the point of view of African women. Allow me to give a brief overview of social/historical/ political context of the discourse on African women's domesticity and education. Socio-historical contexts give important accounts of aspects of "pastness" relevant to women, education, and domesticity and how these views have persisted or changed over time. Discourse on African women's domesticity and education has been influenced by: 1) African culture and tradition, through cultur-

al customs and traditions, 2) Post-colonial or contemporary governments through its policies and regulations and, 3) colonialism which injected Western values into the indigenous cultures thus creating problematic cultural struggles that still persist today. This complex interplay of indigenous expectations, the colonial values, and the present day demands of domesticity create tensions about what it means to be a woman within these opposing and contradictory realms.

Domesticity does not, therefore, only effect women's perceived identity but also reflects back on the social discourses and values within which it is embedded. Domesticity, not only inhibits women's pursuit of education, but also becomes a major source of tension for those women who feel that they are not fulfilling their domestic roles by choosing to pursue higher education. Consequently, this study revealed that the tension between domesticity and education is a big problem. Moreover, this tension and its negative impact on women's education is a major concern, because education is key to the development of the individual and the society.

At the core of the tension between domesticity and education is the need to understand that the problem is not necessarily a problem of women, although it impacts women most. It is a social problem in which women are made to take the brunt of its consequences. It is equally a collective problem of the society at the individual, familial, and state levels and, therefore, African governments must be involved. Divorcing the everyday women's experiences and struggles from the realities of the wider social, economic and political contexts exonerates the society from the responsibility of making women's lives and issues acknowledged as social issues requiring collective social solutions. This privatization of women's experiences has proved detrimental to the status of women and women's education in Africa. The study reveals various impacts of the tension between domesticity and education on the lives of the women. However, I will focus on three major areas that need intervention from the governments:

• Roles of women with regard to motherhood and domesticity
• Assumptions about women's social identity
• Incompatibility of domesticity and education

THE ROLES OF WOMEN WITH REGARD TO
MOTHERHOOD AND DOMESTICITY

Assumptions about the appropriate roles of women in Africa continue to reflect the historical and cultural biases of domesticity. In the present post colonial era, conflicting social, economic, and structural patterns of the traditional, colonial legacy, and modernity still persist. These conflicts continue to impact women's lives. In fact, the more the countries of Africa embrace modernization, the more they feel protective of their cultural heritage for fear of Western cultural hegemony. This fear is nowhere more obvious than in he societal attitudes toward women's education. The fear is augmented if women choose to further their education abroad. This cultural obsession with motherhood and marriage portrayed in the narratives of African women imply a societal patriarchal fear of women who acquire education.

Although the discourse on motherhood and marriage traditionally is associated with the concept of a "good mother" and wife who stayed at home to feed and look after her children, motherhood and wifehood today, for most African women, does not mean physical presence at home. Rather, they imply responsibility for women (married or not) to provide financial and material needs of their children and family. If this is the case, then, women must be given and allowed access to whatever means (education included) that will enable them to have adequate resources.

On the contrary, despite the mismatch between motherhood, as defined by what mothers do and the societal discourse on what mothers should do, the African governments continue to privilege the societal discourses whether or not they inform the reality of women's lived experiences. And because such discourses are constructed within a male dominated contextual understanding of motherhood and wifehood, they constitute the wrong premise on which to base government and state policies and regulations on issues concerning women, including that of education, and marriage. A case in point that reveals women's vulnerability to government marriage regulations concerns my own experience in trying to get travel documents. I could not, as a married woman, obtain my passport to come to the United States to further my studies without a written consent from my hus-

band. This meant that my chances of pursuing higher education as a married woman depended on my husband's authority, which was legitimized and condoned through such government regulations. If my husband did not consent, I would have lost the chance to acquire higher education because of societal limitations placed on me as a married woman.

Tausi (one of my respondents) spoke openly about her conflicts about the future of her marriage when she chose education over domesticity. She said that her "greatest fear is that I will be alone. That I will have no marriage . . . that is something I have to deal with." Most African women are unable to take up or are forced to abandon their studies when husbands threaten to divorce them. Many regulations requiring permission or proof of financial support from husbands are repressive to women and require urgent government intervention. By emphasizing the need for education for all citizens while condoning practices that inhibit women's access to education, the African governments send mixed messages about their commitments to women's concerns.

It follows, therefore, that women who pursue higher education have to deal with consequences of their decisions on a personal basis because the government policies are silent in terms of how such policies are interpreted within the private sphere of the family. Yet we know that governments' social structures, the economic and political ordering concerning families are based on the presumed marriage laws and arrangements.

ASSUMPTIONS ABOUT WOMEN'S SOCIAL IDENTITY

The concept of domesticity further reveals the extent to which African women's identity is hinged on the fact that women are not to function in any context other than home. Therefore, defining and locating African women who choose to function outside of the home becomes problematic. Consequently, being in the category of those who function outside of the home, one becomes a victim of the social wrath. While women struggle for opportunities to further their education abroad, those who do succeed are labeled as social deviants. At the family level, they are ostracized as uncaring mothers and absent wives. At the state level, they are viewed with suspicion as radical and "westernized" women.

Tenji articulated the tension of the "undefinable" educated African women as she related her experience as one of the few women with doctorates who were also mothers, wives, and professionals. Tenji said, "they fear you because they do not know how to define and relate with you." Again while the societal discourse on women's identity is based on the definition of motherhood, the reality is that women are inclined to become not only mothers, but also professionals, workers, and students—identities that are not consistent with the traditional expectations. Consequently, the women are left to deal with the struggles and consequences for choosing education. Because these multiple identities coexist, some may come into prominence and others in oblivion and this may, in turn, restrict or reshape the expectations, attitudes, priorities and practices associated with motherhood. Therefore, the social construction of a monolithic form of motherhood, which is indicative of societal attitudes should not be allowed to control the self image and meaning women create for themselves in their day to day lives. As Tenji's story reveals, although women feel empowered by getting an education, they feel disempowered as rightful members of the society. Education, then, becomes a tool for alienation, not only when women leave to go for further studies abroad, but also when they return home to Africa. Urgent governmental intervention must be geared toward developing and implementing policies that ensure full integration of women in national endeavors. The governments must recognize women's potential as professionals by appointing them to major decision and policy-making positions in the society.

INCOMPATIBILITY OF DOMESTICITY AND EDUCATION

The incompatibility of domesticity and education is, as this study showed, socially constructed. Because this incompatibility is predicated on the monolithic definition of motherhood it does not, therefore, reflect the reality of the multiplicity of women's lives in practice. As Tenji's story showed, although being absent from home limited women's physical interaction with their families, it did not, however, relieve them of emotional family responsibilities. Women continued with other aspects of mothering even when they were away.

Therefore, dichotomizing domesticity and education, purporting that women choose one from the other does not only obscure the "connectedness" and "integrativeness" of these concepts but also suggests that by trying to fulfil both duties women must fail in one, which is not always the case. This assumption does not only show cultural flaw in defining women's roles as monolithic, but also raises questions about the authenticity of show that the reality of the women's lives is that domesticity and education are compatible why, representation of women's reality from the patriarchal male gaze. If women's narratives showed that the reality of he women's lives is that domesticity and education are compatible, then, must women continue to suffer guilt simply because the society believes education and domesticity cannot be compatible. Why must women feel obligated to take up the roles of motherhood while they can choose to enact their other roles? Why must women see themselves as failures if they cannot meet the societal expectations of motherhood, while getting an education promises them a more complete development of their lives? I argue that by focusing on what the society thinks about the capabilities of women, the African governments fail to recognize and tap women as invaluable resources in the development of their countries. I urge the African governments to recognize women as citizens with tremendous potential that can be developed by making education accessible to them without any inhibitions. Women in Africa grow up experiencing a lack of societal encouragement and goodwill through repressive traditions, stereotypes, and male supremacy. I believe Africa's future success depends on the full integration of women in economic, social and political development. Ignoring them will only stifle the dream.

In line with the above, therefore, it is evident that factors that impinge upon women's access to education are complex and pernicious. Although they are not insurmountable they do require support, commitment, and goodwill from your governments, Your Excellencies. In looking at what is constraining women's education in Africa and what can be done to address the issues raised through this letter, I suggest some intervention strategies at both state and continental levels.

- Promote government initiated regional collaborative strategies containing short-term and long-term actions geared toward providing African women with educational incentives. Government initiated collabora-

tive approach will create sustainable forum for sharing information concerning women in different countries of Africa. It is important to note that most of the issues of women in Africa are dealt with by the Non-Governmental Organizations (NGO) and, therefore, such issues do not often get the attention of the government.

- Provide funding and encourage feminist research by, for and with African women. This will offer a unique opportunity to hear women's voices as they offer their perspectives on social issues as well as issues that concern them. Until recently, feminist research on African women has been done by non-African scholars from outside of the continent.
- Include women issues and voice in governance and in decision and policy making, particularly in education. As a priority, include women who hold a feminist perspective to inform government decisions on issues that affect women.
- Strengthen the development, review, and implementation of policies, laws, and practices that are responsive to the concerns and realities of women's lives, at national and local levels.
- Promote activism in gender-relations with a hope to blur the dichotomy between public/private partnerships between men and women in Africa. Encouraging dialogic discourse on such issues as collective sharing of responsibilities, re-thinking women's roles and identity, and rules and regulations (such as marriage regulations) that constrain women's ability to exploit their full potential. Because the current political state in Africa does not allow enough space for transformative gender-relations immediate government intervention is required.

I hope that the issues raised in this letter will illuminate the complexity and deepen your understanding of issues related to women and women's education in Africa. I hope, also, that this understanding will prompt your governments to re-examine and develop policies that are responsive to women. Above all, I hope that you will take the courage and determination expressed through women's narratives about their struggle for higher education as strong indications that women of Africa demand to be trusted to want the best for themselves and their families even if those demands challenge the status quo.

Finally, Your Excellencies, it is apparent that as long as education continues to be the determining factor for social and economic success; as long as the discourse on women's education and policy continue to be based on the societal assumptions of incompatibility between domesticity and education; and as long as women who opt to pursue higher education get ostracized by the society for violating or transcending the confines of domesticity, most women in African (both educated and uneducated) will remain marginalized. I conclude this letter by quoting the words of Tamara, one of my respondents, thus: "Women, even in the academic fields, have to excel and not shy away. But we have to stand for ourselves."

Given the urgency of this situation, the time to act is now.

Thank you very much.

Sincerely,

Mumbi Mwangi

MEMORANDUM

To: Vice Chancellors
 Association of African Universities
 Nairobi

From: Mumbi Mwangi
 Ph.D Candidate
 Iowa State University

Re: Recommendations for Improving the Status of Women and
 Women's Education in African Universities.

Date: May, 2002

This memorandum consists of a brief report of the study that I conducted for a Ph.D. dissertation. The study focused, primarily, on the narratives of experiences of three African women who have pursued and are pursuing higher education in the United States having left their families back home in Africa. They saw the opportunity to further their education as important for their personal and professional development as well as for the improvement of the welfare of their families. I became interested in studying this group of women out of my own experiences as I struggled with the decision to further my own education abroad. My shared experiences with these women and my prior work experiences in one of the universities in African provided the lenses through which I explored in depth, their stories from an insider's perspective.

While higher education is not readily available to most women in African, those who choose to further their education outside their country-of-origin suffer alienation and exclusion from mainstream traditions of the society. The three women I interviewed saw themselves as unique for having defied their homeland traditions that limit the roles of women to domesticity. Consequently, their views about self-improvement through higher education conflated with the pain and the losses they experienced by being away from their families, as well as their emotional and psychological ambivalence as they tried to redefine themselves. Their narratives also revealed how

society, through various social systems and institutions, perpetuate gender inequalities and stereotypes that inhibit African women's access and pursuit of higher education. One of the most entrenched stereotypes in African women's lives is that the African woman must be domestic. This stereotype has been used, among others, to place the African woman in her assumed "natural" location within the domestic sphere. The purpose of this memorandum is to sensitize you, as vice-chancellors of African universities, to the plight of African women who choose to study abroad. I will also share with you some recommendations for improving the status of women ad women's education in Africa.

I interviewed three women, Tausi, Tenji, and Tamara, who were either faculty members in your institutions or joined the universities upon their return back home in Africa. These three women, from different countries of Africa, saw themselves as unique for having defied their homeland traditions that limited the role of women to domesticity. In trying to weave together the two oppositional areas of domesticity and education, the women's narratives reveal anger, helplessness and defiance, as they grapple with personal and social tensions raised by the efforts to attain education. The problem of domesticity is not only a problem effecting choices women make, it is also a problem of inequality between men and women as it reflects gender biases that determine who gets access to higher education and who does not. The problem of domesticity and education is also an identity problem played out in gender stereotypes that define women's identity in relation to the home, thereby, making problematic the identity of those women who choose to pursue education. Further, domesticity does not only effect women's perceived identity but also reflects back on the social discourses and values within which it is embedded. Consequently, domesticity, not only inhibits women's pursuit of education, but also becomes a major source of tension for those women who feel that they are not fulfilling their domestic roles by pursuing higher education. The study revealed that the tension between domesticity and education is a big problem. In addition, its negative impact on women's education is a major concern, particularly, when one recognizes the benefits of education to the development of the individual and the society.

At the core of the tension between domesticity and education is the need to understand that it is a social problem, although it effects mostly

women. The study also found that while traditional beliefs, values and societal attitudes towards women and domesticity no longer reflect the reality of women today, government policies, regulations and attitudes involving women's issues are predicated upon these same values. Unfortunately, these same patriarchal structures, attitudes and values that constrain women are still condoned and promoted by male colleagues in Africa universities. As a result, women's problems are trivialized, assumed or ignored by the administrators and policy makers who are mainly men.

One of the dangers of divorcing everyday women's experiences and struggles from the social, economic and political contexts is that it exonerates the university from taking responsibility and allowing women's issues to be formulated as social issues and problems requiring collective social solutions. This privatization of women's experiences has proved detrimental to the status of women and women's education in most of the universities in Africa. This problem needs to be addressed urgently in order to allow African women to function in academic and national development process unhindered by the societal ideology of domesticity.

Although the study revealed numerous impacts of the tension between domesticity and education on the lives of women, I highlight the following as three major areas that need your attention as well as intervention.

- Women's scholarship at the university
- Fitting educated women into the university system
- Gender equity in promotion procedures and regulations.

WOMEN'S SCHOLARSHIP AT THE UNIVERSITY

Women's scholarship in African universities is problematic. It is characterized by constant struggle as women try to function in a context in which the dominant ideology is that a woman's place is not in academia. Compounded by strong patriarchal beliefs about the role of women in the society, women find themselves struggling for identity and recognition in the academic fields. Patriarchal attitudes, values and structures of African tradition and colonial influence are still dominant today and are

legitimized through the contemporary post-colonial government structures and regulations. Based on the ideology of domesticity, for example, women were excluded from educational activities and, therefore, higher education in Africa has been and continues to be exclusively a male domain. In the early days, going abroad was prestigious and only men were able to go. In addition, because most of the government scholarships to study abroad were given to men, those who hold high administrative positions in the universities are men.

Another factor that explains the small number of women in academia is that most of the educational and scholarship procedures in operation today were modeled with male students in mind. As a result, very few women seek higher education partly because going abroad, though still prestigious, may not be a choice to consider. Because of the societal and institutional pressure for women to conform to domesticity, and the fear of the consequences of deviance, only women who can dare to risk and who are strong enough to grapple with tensions, take advantage of the opportunities. While many women may not choose to go abroad, there is a lack of alternative ways to access higher education in African nations. This mismatch not only translates into a limited presence of women in the academia, but also puts women's educational issues into the oblivion. In her narrative, Tamara says "there are many women with lots of potential who cannot stand for themselves, who cannot make a decision on what they want because they are afraid of societal expectations and comments."

However, those women who, like women in this study, dare the risk encounter many challenges. After they return home all the university want to see is the diploma showing that they have completed their studies. Nobody ever wants to know what difficulties, what emotional turmoil women go through as a result of their decisions to go abroad. There is a dire need to not only deal with the issue of the limited scholarship of African women within our universities but to also value and appreciate the sacrifices they make against all odds to get an education. Alternative ways must be considered to provide more opportunities for African women to access higher education in Africa. The problems women face do not end with returning back to Africa. Rather they are more compounded as women try to fit back into the university.

FITTING EDUCATED WOMEN INTO THE UNIVERSITY ENVIRONMENT

Tenji's narratives exemplify the problems women encounter in trying to fit back into an African university after studying abroad. Tenji is constantly fighting for her right to exist in a hostile male dominated academic environment that works to sabotage her efforts. It follows, therefore, that despite the struggles and pains of getting an education abroad, having a doctorate is not good enough for her to be accepted in the academic community of men. Therefore, although Tenji and other women in the study saw education as a tool for empowerment, it also became a tool for disempowerment and alienation. Though education was a tool for courage in speaking their mind, it became a tool for silence and conformity. Having been assertive before, Tenji finds that non-confrontational approach to dealing with the powers that be is the ultimate choice for survival. What is, however, devastating for Tenji is the helplessness of her situation because she is a woman. Ultimately what Tenji is fighting at the university is not whether or not she is qualified. Rather, she is fighting the hegemonic, sexist prejudices against an educated woman. Surely, patriarchy and male supremacy must never be allowed to quench African women's determination to want to be what they want to be in society. Universities in Africa, as institutions of higher learning and icons of progress, must never be allowed to be sites for women's oppression. Within this hostile university environment, Tenji is not only deprived of an opportunity to exercise her empowerment, but she is intimidated into believing that it is futile for a woman to fight for her rights. She is intimidated also by being reminded about what is at stake if she resisted. But, why must Tenji take solace in the hope that after all, nobody can take her education away from her? Why does she have to wait for academic promotions to be offered to her? Why must the destiny of African women forever be in the hands of men? Why? Ultimately, without focusing on personal satisfaction that one can derive from education, one wonders whether going abroad for further education is worth the struggle for Tenji and other women. The sacrifices women have to endure to get higher education are worthy more than just personal satisfaction. They are worth

every inch of the road to African women's collective destiny and African universities must allow women to take charge.

GENDER EQUITY IN PROMOTION PROCEDURES AND REGULATIONS

The small number of women occupying strategic administrative positions at the university is indicative of the status of women in academia. Despite her position at the university, Tamara's narratives indicate that she is fighting similar battles as Tenji, only at a different level. Although she holds an administrative position Tamara feels that she has not been adequately promoted given the years she has worked for the university in a faculty position. The negligible number of women professors is indicative of gender biases in the structure and promotional procedures at the institution. In her narratives, Tamara articulates her sense of being empowered to make rational decision as an administrator and the reality of the extent to which she is empowered to make those decisions. Tamara, like Tenji, displays a paradoxical situation of empowerment and disempowerment. Additionally, the demands on her as a woman are even higher because she has to prove herself against the assumptions that women are not good enough leaders. Tamara's situation indicates that empowerment for educated African women is not absolute and it depends on the amounts of negotiation she is able to do on everyday basis. It is evident, therefore, that the educated African women in the academia have a long way to go to feel and act empowered, despite the struggles of getting where they are academically. Both Tamara's and Tenji's stories are important in portraying the dimensions of women's struggles for autonomy within a hostile male environment. What compounds the problem of African women in the academy, further, is their negligible number stifling collective agency. Without a voice African women in the academy continue to be silently marginalized and unappreciated. Additionally in the absence of studies like this one which amplifies women's voices, their experiences will forever remain as personal experiences and, therefore, without agency.

Based on the above discussions universities in Africa cannot afford to continue to ignore women and women's education. I recommend the reorganization of the operations of the universities to make them

responsive to women's needs as well as working to improve the status and the morale of women in the academia by taking their issues seriously. I believe that if the vice-chancellors take the initiative to support and sensitize others about issues concerning women within the universities, people will be motivated to see women differently. Specifically, I recommend:

• Creating conducive academic environment responsive to women.
• Improved Educational and Scholarship Programs.
• Women's Improved Status and Morale.

Creating a Conducive Academic Environment Responsive to Women

I believe that as visionary leaders your understanding of continental African women's concerns, commonalties, and differences will inspire others to get involved. It is important to create a conducive environment in our universities where women are encouraged to, rather than prevented from blossoming academically. As institutions of higher learning, universities in Africa must model the changes that society needs in order to change dominant attitudes and perceptions about the roles of women in society. This can only be possible if the universities in Africa are committed to thorough understandings of women's abilities and allowing them to function as full members of academic and civil society. Given such an environment, the universities in Africa will be in a position to tap women's potential that has been blinded by the cultural biases and stereotypes.

Improved Educational and Scholarship Programs

This study has shown that pursuing education has significant meaning to women. However, the struggles over the women's education continue to revolve around the issue of domesticity and what it means to be an educated woman in a society that glorifies motherhood. This study

has emphasized the need for dialogue between universities and women in academia in order to recognize differences of opinion and interests concerning issues that effect women's lives. There is need to revisit the existing university policies and programs to make them responsive to women. As it is evident, going abroad for further studies, although it is considered prestigious, only benefits a small number of women. At the same this study has pointed to the considerable sacrifice that women go through. There is need to develop higher education programs for women locally and make them accessible by organizing them around women's available time periods.

Improved Women Status and Morale

This study has shown that women in academia are marginalized and alienated by societal patriarchal attitudes that permeate the universities resulting to negative stereotyping of women who choose education over domesticity. As a result the overwhelming feeling of powerlessness and isolation has for a long time affected the morale of women in the academia. There must be a deliberately initiated dialogue within the universities about the compatibility of domesticity and education in order to shed light into the challenges of women's lived experiences. Privileging issues that concern women and encouraging feminist research on women will help illuminate their connection to social issues and, therefore, deal with them as such. In addition, dialogues will encourage revisiting societal discourses about issues, like motherhood, domesticity, education, marriage, in the context of present day demands in order to counter the negative implications for the lives of African women. Research on women issues will also help illuminate and shape, through available information, the future direction for continued improved status of women in the academia.

Finally, improving promotion procedures and putting women in administrative positions will not only work to value their input as administrators, but will cultivate the sense of collective responsibility and thereby rekindle their morale. I am recommending the creation of a position of the dean of Women to oversee the concerns of women staff, faculty, and students.

In this memorandum, I have given a thorough insider's account of the problem of women's education in Africa and have also suggested feasible solutions. I have used women's own voices as evidence of their involvement in the demand for changes in African universities' policies on issues concerning women. I am convinced that by giving your total commitment to the issues raised here, there is hope for a brighter future, not only for African women in academia, but for all women in African.

Yours faithfully,

Mumbi Mwangi

Mumbi Mwangi
Iowa State University
U.S.A
April 20, 2002

TO THE YOUNGER GENERATION OF AFRICAN WOMEN

Dear Daughters,

It is with great honor and pride that I write this letter to you. My intent is to share insights from the stories of three remarkable African women about their experiences of leaving their families in African to pursue higher education abroad. Tausi is a doctoral student at Kapa University here in the United States. She is in her late thirties, she is married and has three children. Her husband Kim and the children are all in Africa. Tenji is in her late forties and she attended Pesa University abroad and graduated with a Ph.D. degree in regional planning. Tenji is currently teaching in one of the universities in Africa. The third woman is Tamara. She came to the United States to pursue her Master's degree several years ago. She is in her early sixties and her children are all adults. Currently, she teaches in one of the Universities in Africa and holds an administrative position as the acting director of Students' Affairs. All the three women are successful professionals sharing a common bond. I, too, share this bond.

Speaking with these women through numerous in-depth interviews was a very enriching experience for me. I was able to share my own experiences with them because we have taken similar trajectories as African women pursuing higher education abroad. Our shared status blurred the research/researcher distinction and instead became the main bond that bound us together into a very special relationship. Through the reflective interpretive process, I tried to understand how each of these women defined and acted on the meanings they gave to their actions and decisions at various points in their lives.

Tausi, Tenji, and Tamara are unique for having defied their homeland traditions that limit the roles of women to domesticity. They are also

149

risk-takers who grappled with the personal and social tensions raised by their efforts to attain higher education. Given the strong cultural belief that the African woman must be domestic, these women's progressive decisions to pursue higher education abroad was an indication of tremendous personal strength, courage and determination. They saw education as important for their personal and professional development as exemplified by Tausi's words "without education, you are nothing." Their views about self-improvement through higher education, the pain and loss they experienced by being away from their families, the emotional and psychological ambivalence as they tried to define themselves anew, have invaluable lessons for you, the younger generation of African women. These women's experiences are not only examples of unfeigned determination to pursue that which was important to them, but also showed their courage to accept the consequences even when their actions challenge the norm. I want to share with you three main themes that tied their experiences together 1) Empowerment is in the "dislocation," 2) Success is in the assertiveness, and 3) The future is in the shared consciousness. I also want you to see these themes as knowledge claims that can motivate you to carry on the spirit of courage and determination needed to aspire for a better future for you and for other women in Africa.

EMPOWERMENT IS IN THE "DISLOCATION", IN THE "MOVING AWAY,"IN THE "DIASPORIC EXPERIENCE "

Dislocation is not always a good thing. Dislocation brings about the feeling of hopelessness and despair. "Dislocation," "moving away," and "diaspora," are terms used to describe the dispersal or displacement of people from their place of origin. I choose to use the word displacement to show the actual spatial removal, but I prefer to use the term "diasporic experience" to portray how women experienced this displacement. The concept and the process of diaspora have relevance to the women's experiences for various reasons.

First, the women in the study left their homes and cultures and entered other cultures that were different. Second, they experienced broken ties with the families during the period of absence and because of dif-

ficulties in making connections within the new cultures. Third, although the diasporic experience can be traumatic, "diaspora," for these women provided a place for growth, self-realization, and strength. Diaspora can also provided opportunities that would otherwise not be available in their home countries. All the three women talked about "moving away" as having provided soul-searching moments to reflect on their lives, identity and destiny as women.

In reflecting about what displacement meant to the women, I saw the concept of diasporic experience as important for rethinking African women's lives in several ways. First, it was an opportunity that removed women from their cultural/familial/ context and, therefore, provided them with time to observe and reflect on themselves. Secondly, the concept of "diasporic experience" was useful for encouraging African women to deliberately and consciously remove themselves from everyday routines in order to reflect on themselves. Tausi spoke of her diasporic moment as a time when she was able to reflect on her life by using the metaphor of a "movie." If the process of reflection was so important in helping define her own identity, as Tausi claims, then diasporic space is what every woman in Africa needs.

But creating a diasporic space is not easy. It calls for women to give up their comfort zones and to relinquish the certainties of their identities in order to recreate new identities. Only when women focus on themselves will they begin to discover their true identity and realize the cultural hold that has always oppressed and subordinated them. By focusing on themselves women will be able to see domesticity not as an non-negotiable way of life but something they can do on their own terms and not on the terms of patriarchal institutions. We must strive, as African women, to name ourselves because when we name and define ourselves, we take the power to define from those who have "mis-defined" us. We must remove this power to define from the African traditions that defines us as domestic, from the government that does not view women's issues as social issues, from the patriarchal academic systems that doubts our capabilities as educated women and from researchers who silence our voices and speak on our behalf. We must be assertive in what we believe to be successful.

SUCCESS IS IN THE ASSERTIVENESS

Several insights have emerged out of the process of women interrogating their identity while inhabiting the diasporic space. A major outcome of this self interrogation has included the realization that because most of them looked at the African culture as a "given,'" they were not always cognizant of the extent to which the culture acted on them to reproduce and affirm their cultural identity and location as African women. By taking the culture as given, most African women embraced it without questioning why they do what they do. After interrogating their culture from the diasporic space, these women have realized that culture was unstable and replete with contested codes and representations and that it is possible to recreate and define their "selves" in new ways. Tausi, for example, talked about the danger of cultural silence that denies women the right to speak up and to address the issues that concern them as women. In the same vein, Tenji asserted that if women do not do something for themselves, nobody is going to do it for them. The women realized also that though domesticity as a cultural construct had been used to keep the women in their place, domesticity can be theorized in a way that is less oppressive.

One way to theorize domesticity and education is to see them not as obstacles to women's self-development but as complimentary parts of women's lives. The assertiveness with which the women made the decisions to come over to the United States for further studies is reaffirmed by their determination to create spaces for their continued empowerment after returning home. Tamara's story is significant in portraying the gender dynamics that constrain women's control of their destiny. She asserts that "we have to create spaces for ourselves and other women." Assertiveness is, therefore, important if African women are to advance. Challenging the culture and going against its grain requires adamant assertion by the women themselves. These women in the study have shown that although it is sometimes painful and disorienting, being adamantly assertive is possible. However, the support of other women is also very necessary. This leads me to the next knowledge claim that gives possible direction for the future.

THE FUTURE IS IN THE SHARED CONSCIOUSNESS

One important outcome of the experiences of the women in this study is a strong bond of "shared consciousness." Through narrativizing their experiences, the women in the study have unearthed various cultural practices and beliefs making what has been unconscious, conscious in women's lives. When something is brought from the unconscious to the conscious, it makes us acknowledge that our lives are made of both contexts and each context effects our lives and the things we do. Unearthing the unconscious to conscious, therefore, makes the unconscious important and necessary in understanding our lives and looking for ways to change.

Tenji's idea of the family package being "unreal" is powerful in illuminating the extent to which many women in African may have been practicing domestic roles in unconscious ways. The metaphor of a family package denotes cultural rules and regulations attached to domesticity. As women believe and live these roles, the family package becomes real to them because it is what they do everyday, almost unconsciously. But why would we bother to bring the unconscious to the conscious? Why is it necessary, for example, to examine how women have been practicing their domestic roles in an unconscious way? Having lived domesticity as a Kikuyu woman, and having interacted with women all my life—from my mother, my grandmother, my aunts as well as the rural Kikuyu women, I can firmly say that because women do what they know how to as women in the realm of domesticity, and the fact that other women in the previous generations had done the same things time immemorial, women tend to internalize these activities and beliefs and associate what they do with emotion and morality. Tenji's idea of family package as unreal, therefore, points us back to the point in her life when she was able to question those cultural norms and values she had engaged for so long. This realization not only changed her life, but also gave her a different perspective from which she was able to see herself anew. As the younger generation of African women, it is imperative that you desire to rid yourselves of the unconscious irrational grip of domesticity in order to, not only explore, understand and discover yourselves outside of the cultural confines, but also acknowledge that changes in the perception and meaning of domesticity are possible and necessary.

But, as women in the study have powerfully demonstrated, the power to change the course of African women's lives is in the spirit of shared consciousness. Based on their struggle for education and their determination to change the course of their lives, these women share a common bond. Creating common bonds is important because individual women's problems become shared problems and together women begin to envision new possibilities. Shared consciousness becomes a form of agency and activism that begin with a deliberate facilitation of both collective and individual processes of growth. I strongly believe that the future of African women lies in our ability to name cultural belief and to speak to the hegemonic patriarchal undertones that work to keep African women silent about their experiences. Talking about our experiences and sharing among ourselves will bind us in exclusive relationships. These women pioneers have and will take the brunt of society's disdain by choosing education over domesticity. However, I believe their actions of courage and determination, as well as their insights, will raise critical consciousness that will mobilize you, as the younger generation of women poised on the edge of change, to participate in whatever action necessary to change your lives and change society as well.

I am excited about the possibilities that the future holds for us, for you, and for all of us.

The challenge is yours!

Sincerely,

Mumbi Mwangi

POSTSCRIPT

Growth in consciousness is difficult, often painful. But if we Black women are to grow beyond . . . our alienation from ourselves, from each other, and from our very environment, a shift of consciousness . . . [n]othing short of a revolution of consciousness is needed—a revolution that begins in our hearts and minds as individuals.[1]

I envision the process of doing this study as a culmination of my long professional, academic, emotional, and social journey. Engaging in a reflexive feminist research process has triggered a tremendous growth in consciousness of not only who I am, but also where I have come from, where I am now, and where I want to go. The process has also revolutionalized my consciousness as an individual, because I able to see much more clearly the multiplicity of the "selves" that define me and my subject positions as an African woman, a graduate student, a professional, an educator, a mother, and a wife. This growth of consciousness has not been easy. It has been hard, rigorous, painful, and often ambivalent. However, by taking my respondents along with me, listening to, and interpreting their stories and allowing these stories to reflect on my life through self-reflexivity and reciprocity has not only transformed but also empowered us as women.

The title of this book, *We Will Have Gained Ourselves*, is an affirmation of the hope my respondents and I had for ourselves and other women in Africa. I used this title to epitomize the power, embedded in the process of narrativizing and sharing our experiences, to uncover, inform, and direct our lives and identity as African women. Because feminist methodology validates women's stories as sources of knowledge and insights, this study, therefore, is more than a study. It is a journey of personal and collective self-discovery. It is a chance to speak from our hearts those things that would never have been spoken. It is a chance to accept the pain in our experiences as African women in order to start the healing process. It is a chance to gain ourselves by redefining ourselves anew in our own words and in our own terms. It is a chance to start gaining ourselves by using new words, envisioning new identities and finding new spaces in order to take our rightful place in academia, in our families, in our countries, and in our society. However, the journey toward gaining ourselves as African women does not end with the conclusion of this study. Rather, this study dares African women to embrace this continuous, uncharted, and uncertain journey into a future full of possibilities. And because of the envisioned possibilities, the journey will be worth every step, every day, every year, every life. It will truly be a journey worth while.

REFERENCES

Abagi, O. (1995). Gender equity as a challenge for implementing Education For All (EFA): Recounting gender issues in the provision of education for all in Kenya. *Basis Education Forum*, 6, pp. 35-42.

Abagi, O., & Wamahiu, S. (1995). *Household based factors and school participation of girls: Lessons from the existing surveys.* Nairobi: Kenya Academy Science Publishers.

Afshar, H. (1987). *Women, state, and ideology: Studies from Africa and Asia.* Albany: State University of New York Press.

Aina, O. (1998). African women at the grassroot: The silent partners of the women's movement. In O. Nnaemela, (Ed.), *Sisterhood, feminism and power: From Africa to the Diaspora.* Trenton: Africa World Press.

Allen, K.R., and Baker, K.M. (1992). Ethical and epistemological tensions in applying a postmodern perspective to feminist research. Psychology of Women Quarterly, 16, pp. 1-5.

Andersen, B.H., Gudorf, C.E., & Pellanen, M.D. (1987). (Eds.). *Women's consciousness, women's conscience.* San Francisco: Harper & Row Publishers.

Andersen, M.L. (1983). *Thinking about women: Sociological and feminist perspectives.* New York: Macmillan.

Aidoo, A.A. (1984). "To be a woman." In R. Morgan (Ed). *Sisterhood Is Global.* New York: Doubleday.

Aubrey, L. (2001). "Gender, development and democratization in Africa." *Journal of Asian and African Studies*, 34 (1) p. 87-111.

Bakan, D. (1996). Some reflections about narrative research and hurt and harm. In R. Josselson, (Ed.), *Ethics and process: The narrative study of lives*. Thousand Oaks: Sage Publications.

Baylies, C., and Bujra, J. (1993). Challenging gender inequalities. Review of African Political Economy, (56) p. 5-14.

Behar, R. (1996). *The vulnerable observer: Anthropology that breaks your heart*. Boston: Beacon Press.

Bennaars, G. (1995). "Gender education and the pedagogy of difference: The African predicament." *Basic Education Forum*, (6) pp. 23-34.

Berger, I., and White, E.F. (1999). *Women in sub-Saharan Africa: Restoring women to history*. Bloomington: Indiana University Press.

Bhalalusesa, E. (1998). "Women's career and professional development: Experiences and challenges." *Gender and Education*, 10 (1) pp. 21-33.

Bloom, L.R. (1996). "Stories of one's own: Non unitary subjectivity in narrative representation." *Qualitative Inquiry*, 2 (2) pp. 176-197.

Bloom, L.R. (1997). "Locked in uneasy sisterhood: Reflections on feminist methodology and research relations." *Anthropology & Education Quarterly*, 28 (1) pp. 111-122.

Bloom, L.R. (1998). *Under the sign of hope: Feminist methodology and narrative interpretation*. Albany: State University of New York Press.

Bloom, L.R., and Munro, P. (1995). "Conflicts of selves: Non-unitary subjectivity in women administrators' life history." In J.A. Hatch, & R. Wisniewski, (Eds.), *Life-history narratives*. Washington, D.C: The Palmer Press.

Brunner, C.H. (1993). (Ed.) *African women's writing*. London: Heinemann.

Bogdan, R.C., and Biklen, S.K. (1998). *Qualitative Research in Education* (3rd ed.). Boston: Allyn and Bacon.

Bulbeck, C. (1998). *Re-orienting Western feminisms: Women's diversity in a postcolonial world*. Cambridge: Cambridge University Press.

Bystedzienski, J.M., and Resnik, E. (Eds.). *Women in cross-cultural transitions*. Bloomington: Phi Delta Kappa Educational Foundation.

Chambers, R. (1999). *Whose reality counts?: Putting the first last*. London: The Bath Press.

Christman, J.B. (1988). "Working in the field as the female friend." *Anthropology & Education Quarterly*, 19 pp. 70-85.

Cock, J., and Bernstein, A. (2001). "Gender differences: Struggles around "needs" and "rights" in South Africa." *National Women Studies Association Journal*, 13 (3) pp. 138-152.

Collins, P.H. (1990). *Black feminist thought: Knowledge, consciousness, and the politics of empowerment.* Boston: Unwin Hyman.

Collins, P.H. (1998). *Fighting words: Black women and the search for justice.* Minneapolis: University of Minnesota Press.

Collins, R., and Makowsky, M. (1998). *The discovery of society* (3rd ed.). New York: McGraw-Hill.

Constas, M.A. (1997). "The changing nature of educational research and a critique of postmodernism." *Educational Researcher*, 27 (2) pp. 26-33.

Conrad, S.P. (1976). *Perish the thought: Intellectual women in romantic America.* New York: Oxford University Press.

Cronn-Mills, K.J. (1997). "Performance and problematizing in rhetorical culture." Unpublished Ph. D. dissertation. ISU

Cutrufelli, M.R. (1983). *Women of Africa: Roots of oppression.* London: Zed Press.

Denzin, N.K. (1997). *Interpretive Ethnography: Ethnographic Practice for the Twentieth Century.* Thousand Oaks: SAGE Publications.

Denzin, N.K., and Lincoln, Y.S. (Eds.). (2000). *Handbook of qualitative research.* (2nd ed.). Thousand Oaks: Sage Publications, Inc.

Desai, D. (2000). "Imaging difference: The politics of representation in multi-cultural art education. Studies in Art Education." *Journal of Issues and Research*, 41 (2) pp. 114-129.

Dangarembga, T. (1988). *Nervous conditions.* Seattle: Seal Press.

DeVault, M. (1999). *Liberating method: Feminism and social research.* Philadelphia: Temple University Press.

Ellingson, L.L. (1998). "Then you know how I feel: Empathy, identification, and reflexivity in fieldwork." *Qualitative Inquiry*, 4 (4) pp. 492-514.

Ellsworth, E. (1994). "Representation, self-representation, and the meanings of difference." In R.A. Martusewicz and W.M. Reynolds (Eds.), *Inside/Out: Contemporary critical perspectives in education.* New

York: St Martin's Press.

Emecheta, B. (1979). *The joys of motherhood*. New York: George Braziller.

Emecheta, B. (1986). *Head above water*. London: Blackrose Press.

England, P. (1993). (Ed.). *Theory on gender: Feminism on theory*. New York: Aldine De Gruyter.

Etter-Lewis, G., and Foster, M. (1996). (Eds). *Unrelated Kin: Race and gender in women's personal narratives*. New York: Routledge.

Etter-Lewis, G. (1991). "Black women's life stories: Reclaiming self in narrative text." In S.B. Gluck, and D. Patai, (Eds.), *Women's words: The feminist narrative of oral history*. New York: Routledge.

Ferree, M.M., Lorber, J., and Hess, H.B. (Eds.) (1999). *Revisioning gender*. Thousand Oaks: Sage Publications, Inc.

Flower, L. (1996). "Negotiating the meaning of difference." *Written Communication*, 13 (1) pp. 44-92.

Forum for African Women Educationalists (FAWE). (1996). The education of girls and women in Africa. Information booklet. Nairobi.

Foucault, M. [1977] (1984). "Discipline and Punish." Translated by Alan Sheridan. In P. Robinow, (Ed.), *The Foucault Reader*. pp. 170-225. New York: Pantheon Books.

Frese, P.R., and Coggeshall, J.M. (Eds.) (1991). *Transcending boundaries: Multi-disciplinary approaches to the study of gender*. New York: Bergin & Garvey.

Garey, A.I. (1999). *Weaving work and motherhood*. Philadelphia: Temple University Press.

Geiger, S. (1999). "Women and gender in Africa." *African Studies Review*, 42 (3) pp. 20-33.

Gilroy, P. (1993). *The Black Atlantic: Modernity and double consciousness*. Cambridge: Harvard University Press.

Giroux, H.A. (1992). *Border crossings: Cultural workers and the politics of education*. New York: Routledge.

Glaser, B.G. and Strauss, A.L. (1967). *The discovery of grounded theory: Strategies for qualitative research*. Chicago: Aldine.

Gleick, J. (1988). *Chaos: Making a new science*. London: Penguin Group.

Glenn, E.N., Chang, G., and Forcey, L.R. (1994). (Eds.). *Mothering: Ideology, experience, and agency*. New York: Routledge.

Glesne, C., and Peshkin, A. (1992). *Becoming qualitative researchers: An introduction*. New York: Longman.

Goldberger, N.R., Tarule, J.M., Clinchy, B.M., and Belenky M.F. (Eds.). (1996). *Knowledge, difference, and power: Essays inspired by women's ways of knowing*. New York: Basic Books.

Haraway, D. (1991). *Simians, cyborgs, and women: The reinvention of nature*. New York: Routledge.

Harding, S. (Ed.). (1987). *Feminism and methodology: Social science issues*. Bloomington: Indiana University Press.

Harding, S. (1991). *Whose science? Whose knowledge?: Thinking from women's lives*. New York: Cornell University Press.

Hartsock, N. (1998). *Feminist standpoint revisited and other essays*. Boulder: Westview Press.

Hatch, J. A., and Wisniewski, R. (Eds.). (1995). *Life history and narratives*. Washington, D.C.: The Falmer Press.

Hay, J. M., and Stitchter, S. (1995). (Eds.). *African women South of Sahara*. (2nd ed). New York: John Wiley, & Son, Inc.

Hooks, B. (1989). *Talking back: Thinking feminist, thinking black*. Boston: South End Press.

Jacobs, M.E., and Munro, P. (1995). "Palimpsest: (Re)reading women's lives." *Qualitative Inquiry*, 1 (3) p. 327.

Jacobson, D. (1991). *Reading ethnography*. New York: State University of New York.

Jaggar, A.M. (1989). "Love and knowledge: Emotion in feminist epistemology." In A.M. Jaggar and S. Bordo (Eds.), *Gender, body, knowledge*. New Brunswick: Rutgers University Press.

Jarrett-Macauley, D. (1996). *Reconstructing womanhood, reconstructing feminism: Writings on Black women*. New York: Routledge.

Josselson, R. (1996). (Ed.). *Ethics and process. The narrative study of lives*. Thousand Oaks: Sage Publications.

Kaziboni, T. (2000). "Picking up threads—women pursuing further studies at the University of Zimbambwe." *Studies in the Education of Adults*, 32 (2) p. 229

Kelly, G.P., & Elliot, C.M. (1982). *Women's education in the Third World: Comparative perspectives*. Albany: State University of New York Press.

Kenyatta, J. (1962). *Facing Mount Kenya: The tribal life of the Gikuyu.* New York: Vintage Books.

Kesselman, A., McNair, L.D., and Schniedewind, N. (1999). (Eds.). *Women images and realities: A multicultural anthology.* (2nd ed.). California: Mayfield Publishing Company.

Kiluva-Ndunda, M.M. (2001). *Women's agency and educational policy: The experiences of the women of Kilome, Kenya.* Albany: State University of New York Press.

Kolmar, W., and Bartkowski, F. (2000). (Eds). *Feminist Theory: A reader.* California: Mayfield Publishing Company.

Kushner, S. (2000). *Personalizing evaluation.* Thousand Oaks: Sage Publications Inc.

Krieger, S. (1991). *Social science and the self: Personal essays on art form.* New Brunswick: Rutgers University Press.

Lather, P. (1986). "Research as praxis." *Harvard Educational Review,* 56 (3) pp. 257-277.

Litt, J.S. (2000). *Medicalized motherhood: Perspectives from the lives of African-American and Jewish women.* New Jersey: Rutgers University Press.

Lorde, A. (1984). *Sister outsider: Essays and speeches.* New York: Crossing.

Luttrell, W. (1997). *School Smart and motherwise: Working-class women's identity and schooling.* New York: Routledge.

Macauley. D.J. (1996). (Ed.). *Reconstructing womanhood, reconstructing feminism: Writings on Black women.* New York: Routledge.

Mama, A. (1995). *Beyond the masks: Gender, race and subjectivity.* New York: Routledge.

Mani, L. (1990). "Contentious traditions: The debate on Sati in colonial India." In S. Kumkum, and S. Vaid (Eds.), *Recasting women: Essays in Indian colonial history.* New Brunswick: Rutgers University Press.

Marcus, G. and Clifford, J. (1986). (Eds.) *Writing Culture: The poetics of ethnography.* Berkely: University of California Press.

Martel, A., and Peterat, L. (1994). "Margins of exclusion, margins of transformation: The place of women in education." In R.A. Martusewicz, and W.M. Reynold, (Eds), *Inside/out: Contemporary critical perspectives in education.* New York: St Martin's Press.

Mbilinyi, M. (1992). "Research methodologies on gender issues." In R. Meena (Ed.), *Gender in Southern Africa: Conceptual and theoretical issues.* Harare: SAPES Books.

Mbilinyi, M., and Meena, R. (1991). "Reports from four women's groups in Africa." *SIGNS: Journal of Women in Culture and Society,* 16 (4) pp. 846-848.

McLeer, A. (1998). "Saving the victim: Recuperating the language of the victim and reassessing global feminism." *HYPATIA: A Journal of Feminist Philosophy,* 13 (1) pp. 41-55.

Merchant, B.M., and Willis, A.I. (2001). (Eds.). *Multiple and intersecting identities in qualitative research.* New Jersey: Lawrence Erlbaum Associates, Publishers.

Mikell, G. (1997). (Ed.). *African feminism: The politics of survival in Sub-Saharan Africa.* Philadelphia: University of Pennsylvania Press.

Miles, R. (1985). Women and power. London: McDonald.

Mohanty, C.T. (1991). "Under Western eyes: Feminist scholarship and colonial discourses." In C.T. Mohanty, A. Russo, and L. Torres (Eds.), *Third World women and the politics of feminism.* Bloomington: Indiana University Press.

Munro, P. (1995). "Multiple 'I's: Dilemmas of life-history research." In J. Jipson, P. Munro, S. Victor, K.F. Jones, and G. Freed-Rowland. (Eds.) *Repositioning feminism and education: Perspectives on educating for social change.* Westport: Bergin & Garvey.

Munro, P. (1998). *Subject to fiction: Women teachers' life-history narratives and the cultural politics of resistance.* Philadelphia: Open University Press.

Mwangi, M. (1992). "Teaching of Home Economics in Kenya." Unpublished thesis for Master's degree in education. Kenyatta University, Nairobi, Kenya.

Mwangi, M. (1998). Unpublished manuscript of African women's experiences. (Fieldnotes).

Narayan, U. (1997). *Dislocating cultures: Identities, traditions and Third World feminism.* New York: Routledge.

Narayan, U. (2001). "Thinking about the cultures in multiculturalism." Unpublished paper presented at the conference on "Multiculturalism and Liberal Education." Seattle University.

Narayan, U., and Harding S. (1998). (Eds.). "Border crossings: Multicultural and post-colonial feminist challenges to philosophy (part 1)." *Hypatia: Journal of Feminist Philosophy*, 13 (2) pp. 1-202.

Nicholson, L.J.C. (1990). (Ed.). *Feminism/Postmodernism*. New York: Routledge.

Nicholson, L. (1997) (Ed). *The second wave: A reader in feminist theory*. New York: Routledge.

Nicholson, L. (2000). "Cultural relativism." Unpublished manuscript.

Nnaemeka, O. (1998). (Ed.). *Sisterhood, feminisms, and power: From Africa to the Diaspora*. Trenton: Africa World Press.

Norguay, N. (1990). "Life history research: Memories, schooling and society." *Cambridge Journal of Education*, 20 (3) p. 291.

Nystrom, P.S. (1999). "Narayan's critique of the anthropological perspective." Unpublished manuscript. Iowa State University.

Oakley, A. (1981). "Interviewing women: A contradiction in terms." In Helen Roberts, (Ed). *Doing feminist research*. London: Routledge.

Odim, C.J. (1996). "Mirror images and shared standpoints: Black women in Africa and the African Diaspora." *ISSUE*. African Studies Association, 24 (2) pp. 18-23.

Okeke, P.E. (1996). "Postmodern feminism and knowledge production: The African context." *Africa Today*, 43 (3) pp. 21-30.

Okeke, P.E. (1997). "African/Africanist feminist relations: Restructuring the agenda/agency." *ISSUE*. African Studies Association. 25 (2) pp. 34-37.

Olneck, M. (2000). "Can multicultural education change what counts as cultural capital?" American Educational Research Journal, 37 (2) pp. 317-348.

Otieno, T.N. (1998). "Kenyan women: Challenges and strategies toward higher educational advancement." *International Journal of Educational Reform*, 7 (4) pp. 352-360.

Oyewum, O. (2000). "Family bonds/conceptual binds: African notes on feminist epistemologies." *Signs: Journal of Women in Culture and Society*, 25 (4) pp. 1092-1098.

Pala, A. (1995). (Ed.). *Connecting across cultures and continents: Black women speak out on identity, race and development*. New York: UNIFEM.

Pamphilon, B. (1999). "The zoom model: A dynamic framework for the analysis of life histories." *Qualitative Inquiry*, 51 (3) p. 393

Parrenas, R.S. (2001). "Mothering from a distance: Emotions, gender, and inter-generational relations in Filipino transnational families." *Feminist Studies*, 27 (2) pp. 361-390.

Patton, M.Q. (1990). *Qualitative evaluation and research methods* (2nd ed.). Newbury Park, CA: Sage Publication, Inc.

Personal Narrative Group. (1989). *Interpreting women's lives: Feminist theory and personal narratives.* Bloomington: Indiana University Press.

Polkinghorne, D.E. (1995). "Narrative configuration in qualitative analysis." In J.A. Hatch and R. Wisniewski (Eds.). *Life history and narrative.* Washington, D.C.: Falmer.

Rabinow, R. (1994). (Ed.). *The Foucault reader.* New York: Pantheon Books.

Reinhart, R. (1998). "Fictional methods in ethnography: Believability, specks of glass and Chekhor." *Quarterly Inquiry*, 4 (2) pp. 200-225.

Reinharz, S. (1992). *Feminist methods in social research.* New York: Oxford University Press.

Rich, A. (1979). *On lies, secrets, and silence: Selected prose.* New York: W.W. Norton & Company.

Richardson, L. (1997). *Fields of play: Constructing an academic life.* New Brunswick: Rutgers University Press.

Riessman, C. K. (1993). Narrative analysis. Qualitative Research Method Series, 30. Newbury Park: Sage Publication.

Rosenau, P.M. (1992). *Post-modernism and the social sciences: Insights, inroads and intrusions.* New Jersey: Princeton University Press.

Rosenwald, G.C. (1996). "Making whole: Methods and ethics in mainstream and narrative psychology." In R. Josselson (Ed.), *Ethics and process: The narrative study of lives.* Thousand Oaks: Sage Publications.

Rogers, C., and Freiberg, J.H. (1994). *Freedom to learn* (3rd ed.). New York: Merril.

Ruddick, S. (1989). *Maternal thinking: Towards politics of peace.* London: The Women's Press.

Sachs, C.E. (1996). *Gendered fields: Rural women, agriculture, and environment.* Boulder: Westview Press.

Schwandt, T.A. (1989). "Solutions to paradigm conflict: Coping with uncertainty." *Journal of Contemporary Ethnography*, 17 (4) pp. 379-407.

Schur, E. (1984). *Labeling women deviant: gender, stigma, and social control*. New York: Random House.

Shreve, A. (1989). *Women together, women alone: The legacy of the consciousness-raising movement*. New York: Viking Penguin.

Sidel, R. (1990). *Growing up in the shadow of the American dream*. New York: Viking Penguin

Smith, D.E. (1987). *The everyday world as problematic: A feminist sociology*. Boston: Northwestern University.

Smith, D. (1990). *The conceptual practice of power: A feminist sociology of knowledge*. Boston: Northeastern University Press.

Spelman, E. (1988). *Inessential woman: Problems of exclusion in feminist thought*. Boston: Beacon Press.

Stamp, P. (1986). "Kikuyu Women's self help groups: Towards an understanding of the relation between sex-gender system and mode of production in Africa." In C. Robertson, and I. Berger (Eds.), *Women and class in Africa*. New York: Africana Publishing Company.

Steady, F.C. (1991). (Ed.). *The Black woman cross-culturally*. Massachusetts: Schenkman Publishing, Inc.

Stewart, A. (1998). "The ethnographer's method." *Qualitative Research Methods Series*, 46. Thousand Oaks: Sage Publications.

Stivers, C. (1993). "Reflections on the role of personal narratives in social science." *Journal of Women in Culture and Society*, 3 (2) pp. 408-429.

Strauss, A. (1987). *Qualitative analysis for social scientists*. Cambridge: Cambridge University Press.

Taylor, S.J., and Bogdan, R. (1998). *Introduction to qualitative research methods*. New York: John Wiley & Sons, Inc.

Terborg-Penn, R., Harley, S., and Rushing, B. (1995). (Eds.). *Women in Africa and the Diaspora*. (3rd Ed.). Washington, D.C.: Howard University Press.

Thiong'o, N.W. (1994). *Decolonising the mind: The politics of language in African literature*. Nairobi: Heinemann.

Tierney, W.G. (1998). "Life history: Subjects foretold." *Qualitative Inquiry*, 4 (1) pp. 49-72.

Tripp, A.M. (2000). "Rethinking difference: Comparative perspectives from Africa." *Signs: Journal of Women in Culture and Society*, 25 (3) pp. 549-675.

Umansky, L. (1996). *Motherhood reconceived: Feminism and the legacies of the sixties*. New York: New York Press.

Usita, P.M. (2001). "Interdependency in immigrant mother-daughter relationships." *Journal of Aging Studies*, 15 (2) pp. 183-200.

Van Maanen, J. (1988). *Tales of the field: On writing ethnography*. Chicago: University of Chicago Press.

Van Manen, M. (1990). *Researching lived experience: Human science for action sensitive pedagogy*. New York: State University of New York Press

Walters, R.W. (1993). *Pan Africanism in the African Diaspora: An analysis of modern Afrocentic political movements*. Detroit: Wayne State University Press.

Walker, R. (1995). (Ed). *To be real: Telling the truth and changing the face of feminism*. New York: Anchor Books.

Wanjama, L.N., and Kimani, E.N. (1995). "Gender specific constraints to education of girls: A justification of making gender a critical variable in education." *Basic Education Forum*, (6) pp. 43-49.

Weedon, C. (1999). *Feminism, theory and the politics of difference*. Malden: Blackwell Publishers Inc.

Weiler, K. (1988). *Women teaching for change: Gender, class, and power*. New York: Bergin & Garvey Publishers.

Wolf, D.L. (1996). (Ed.). *Feminist dilemmas in fieldwork*. Boulder: Westview Press.

Zeller, N. (1995). "Narrative strategies for case report." In J.A. Hatch and R. Wisniewski (Eds.), *Life history and narratives*. Washington DC: The Falmer Press.

ACKNOWLEDGEMENTS

I am grateful to many special people who assisted and supported me in the process of doing this research. I am indebted to Tausi, Tenji, and Tamara for allowing me into their lives and sharing their experiences without which this study would not have been possible.

I want to express my highest gratitude to my major professor, Dr. Leslie Rebecca Bloom, for inspiring me professionally and academically. Leslie, thank you for your guidance and support throughout my program of study, and especially in the grueling process of doing this study. Thank you above all for teaching me qualitative research and opening new and exciting horizons to my academic world. I will forever be grateful.

Thanks also to my program of study (POS) committee members: Dr. Jill M. Bystydzienski, Dr. Jacqueline Litt, Dr. Deborah Kilgore, Dr. Teresa McCormick, and Dr. David B. Owen. Your scholarly and professional guidance was invaluable. Thank you for believing in me and for providing challenging opportunities for exploring my academic potential. You established an unthreatenting and nurturing environment that enabled my academic ability to flourish. Your guiadance, mentoring, and generosity tremendously influenced my ability to realize this goal.

Sincere thanks to the Nystrom family, and especially to Marck and Pam Nystrom for the constant prodding and encouragement to get my

work done, and for being there all along for me. I am also appreciative of Judy Weiland, Elaine Smuck, Kathy Svec, Nancy Woods, and Melinda Gallagher for the technical support and Jo Ann Rogers, Peggy Talbert, and Norah Gresch for their constant encouragement. Special thanks to MaryJo Mertens, the executive director of the Iowa State Memorial Union, for her continued support and encouragement, and for showing interest in my academic progress over the years. She has been an inspiration to me.

Finally, many thanks go to my family. I am indebted to my mother, Perpetua Wambui Wango, for instilling in me the courage and determination to succeed; to my sisters, Professor Olive Mugenda and Mrs. Wairimu Mbugua, and my brother, Kamau Wango, for their love and support; and to my darling children, Njeri, Wambui, Mwihaki, Mwangi, Karungari, Nyoike, and Wairimu. This academic journey has been as painful as it has been joyous for us as a family. However, my greatest hope is that this achievement will inspire you to look beyond the pain of my absence from your lives and reach out to the best that there is in life. Indeed, this achievement is much more yours than it is mine. Thank you all for making this accomplishment a dream come true.